MOSS
From forest to garden:
a guide to the hidden world of moss

ULRICA NORDSTRÖM

PHOTOGRAPHY BY HENRIK BONNEVIER
ILLUSTRATIONS BY STEFAN ENGBLOM

THE COUNTRYMAN PRESS
A division of W. W. Norton & Company
Independent Publishers Since 1923

It was not merely green; it was frantically green. It was so bright in its verdure that the color nearly spoke, as though – smashing through the world of sight – it wanted to migrate into the world of sound. The moss was a thick, living pelt, transforming every rock surface into a mythical, sleeping beast.

Now the miniature forest below her gaze sprang into majestic detail. She felt her breath catch. This was a stupefying kingdom. This was the Amazon jungle as seen from the back of a harpy eagle. She rode her eye above the surprising landscape, following its paths in every direction. Here were rich, abundant valleys filled with tiny trees of braided mermaid hair and minuscule, tangled vines . . . She felt herself growing breathless. 'This was the entire world.' This was bigger than a world. This was the firmament of the universe, as seen through one of William Herschel's mighty telescopes. This was planetary and vast. These were ancient, unexplored galaxies, rolling forth in front of her – and it was all right here!

The Signature of All Things, Elizabeth Gilbert

First published as *Mossa* in Sweden by Natur & Kultur 2018
First published in Great Britain by Michael Joseph 2019
First published in the United States by The Countryman Press 2019

Printed in Italy

For information about permission to reproduce selections from this book, write to
Permissions, The Countryman Press, 500 Fifth Avenue, New York, NY 10110

For information about special discounts for bulk purchases, please contact
W. W. Norton Special Sales at specialsales@wwnorton.com or 800-233-4830

The Countryman Press
www.countrymanpress.com

A division of W. W. Norton & Company, Inc.
500 Fifth Avenue, New York, NY 10110
www.wwnorton.com

978-1-68268-483-2

10 9 8 7 6 5 4 3 2 1

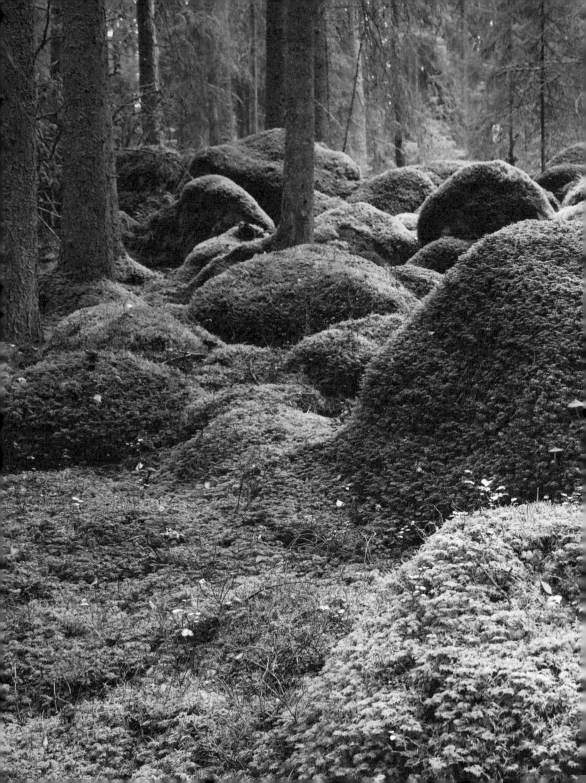

A tribute to moss

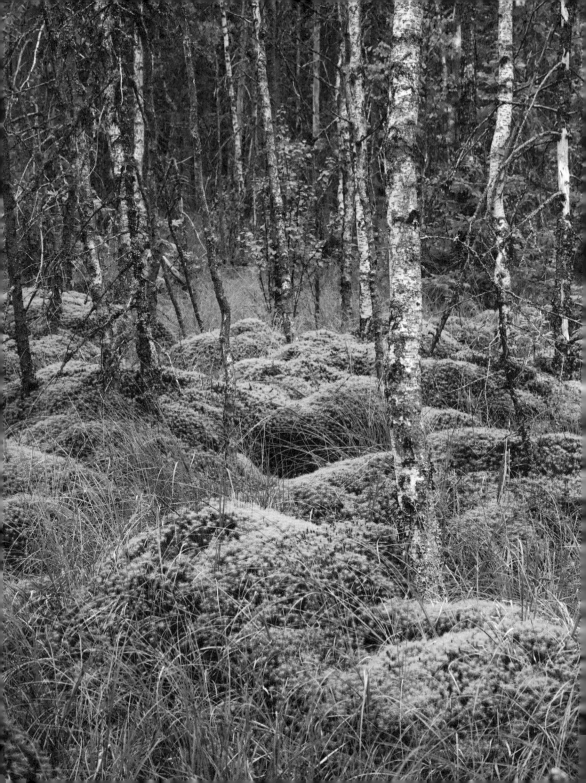

I was thirteen years old and training with my local orienteering club in a forest outside Kalix in northern Sweden when I first gave moss any thought. In the milk-white fog the map had lost its meaning and the north-eastern compass needle did not help me. I shouted 'Hello!', but nobody answered. The woods were silent and the fog was thick between the straight lines of the pines.

I was lost, but not afraid, and remember thinking, 'But if the animals live here then I can survive for at least two days. I can eat berries, and if I get cold I can cover myself with the moss.'

After three hours, I managed to find a road where I was picked up by a couple in a green car who gave me a ride to a nearby city. I was able to borrow a phone at a petrol station and called my mother who came and picked me up.

Of course, I did not know much about moss. But its presence in the woods in the area where I had grown up had worked its way into my consciousness. I perceived it as soft, protective and comforting. To my mind, it was something that humans and animals could turn to in comfort if they got lost in the forest.

It turned out that my childish intuition wasn't entirely foolish. Throughout history, people in Scandinavia and further afield have appreciated the practical benefits of moss, using it for wound dressings, for crafts, and to insulate timber houses. In gardening, though, moss has more commonly been seen as an unwanted presence and something that should be eradicated from garden lawns. This is strange. In the winter, moss is the only plant that can cover our bare, cold fields with what so many long for during the winter months: magical, soothing greenery. The beauty of moss can be enjoyed all year round.

While writing this book, photographer Henrik Bonnevier and I went to places where moss is anything but invisible. We visited gardens around the world where the presence of moss astonished us. We gained valuable tips and learned how to study moss and use it in various gardening and craft projects, and we met people who have

dedicated their lives to moss, whether through the pursuit of knowledge or for creativity and crafts.

Many people I meet have difficulty understanding exactly what is so amazing about moss. Those who love moss sometimes see it as representing the passage of time, softness, nature and stability. Others speak about its playful varied shapes, structures and colour, and about moss's ability to spread and flourish in places where few other plants can survive. Perhaps that is what creates this wonder and admiration: that mosses are completely unique in their structure, appearance and ways of growing and living. Moss is so small that the vast majority of people barely notice it at all but at the same time it is widespread and almost always evergreen.

The purpose of this book is to give an introduction to moss and to spread knowledge that is useful for those who want to learn more about this outstanding group of plants. And I promise, once you have entered the exciting world of moss, you will want to see more of it. As a photographer, Henrik spent a couple of weeks working on this book: 'Now I suddenly see moss everywhere!'

Ulrica Nordström

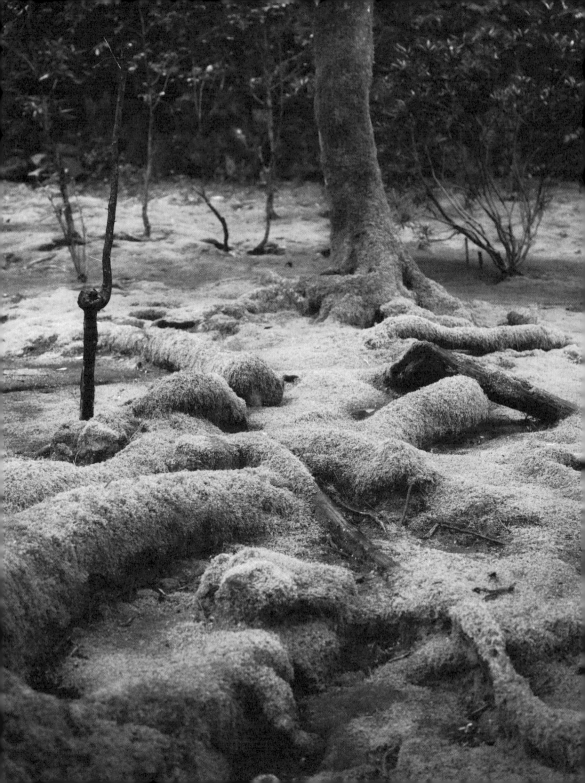

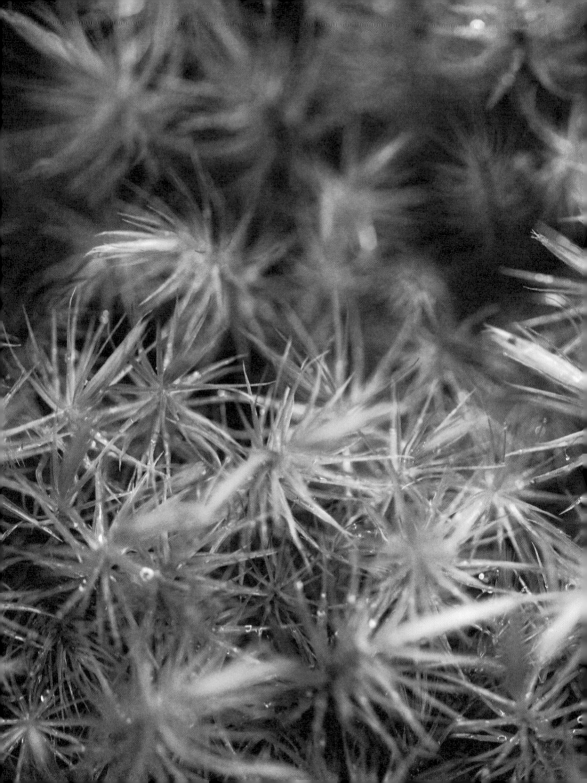

Mosses: a world of miniature plants

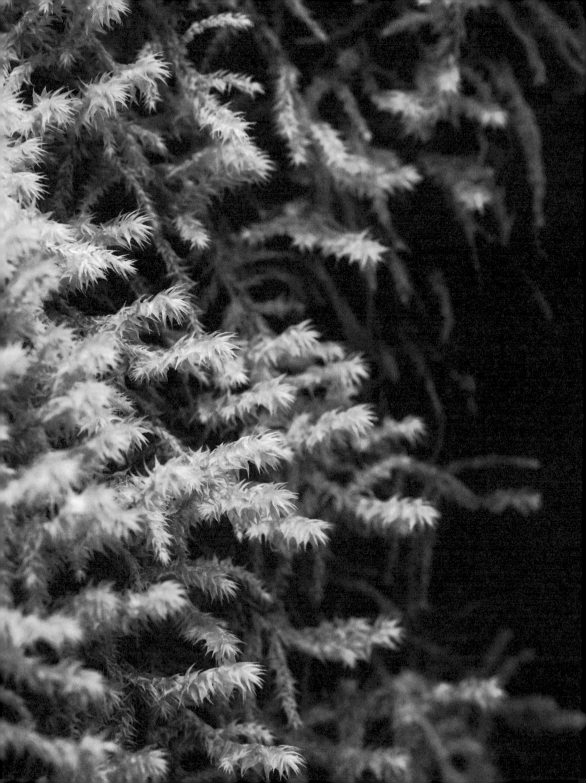

When we visit the countryside it is not difficult to pay attention to and marvel at different plants and animals. Most of us know the names of at least some trees, birds or flowers, and maybe even know something about their living conditions. Taking a break and admiring a beautiful bed of moss in the woods is also an experience, but we rarely study the plant world's miniature occupants close up. This is a shame, because when you do stop to admire moss, it reveals a whole new world of different magical shapes, colour shades, structures and growth patterns.

The Plant Kingdom, as humans have categorised it, consists of green plants that are divided into three different divisions: the green algae, the mosses and the vascular plants. The mosses are an ancient group of plants and they first evolved and appeared more than 350 million years ago. Moss grows in all parts of the world, from the Arctic to the tropics. Today, it is estimated that there are about 20,000 species of moss on Earth, of which more than 1700 species are found in Europe and almost 800 in Britain.

Moss anatomy

Mosses differ in several ways from other types of plant. In contrast to vascular plants, which include the trees and shrubs that we all know as plant life, and which have a network of tubes via which the plant transports nutrients and water to its various tissues, mosses have a relatively simple structure. Almost all mosses consist of stems and leaves, but there are also some species with a trunk, a type of 'body'. The leaves are covered with wax layers and have pores, and – unlike vascular plants – the plant lacks real roots. Instead of roots, they have little hairs or fasteners, called rhizoids. The main task of a rhizoid is to anchor the moss to its substrate. Rhizoids don't absorb or transport water or nutrients, as plant roots do. Instead, mosses must acquire water and nutrition through the cells of their leaves and stem. Thus the lack of a vascular system

limits their ability to grow to large sizes. Whereas other plants can transport water and nutrients from roots and up stems and along trunks to faraway leaves and flowers, mosses do not have the same advantage. So, they grow low to the ground. They grow either upright in tufts, which are called acrocarps, or along the surface of the ground, forming carpets, which are called pleurocarps.

The rate of moss growth is low for much of the year and, therefore, mosses can grow with relatively little nutrition and light. They have an exceptional ability to survive through drought and cold by going into hibernation. There are researchers who revived a 1600-year-old moss that had been frozen in Antarctica. In Scandinavian forests spores have been found that are at least 500 years old. However, mosses are directly dependent on moisture to reproduce and therefore thrive in environments with high humidity. They prefer damp conditions where water is abundant, and they have difficulty surviving in sunny or windy environments because both these factors reduce the water content of the air and soil around the plant.

Mosses are usually divided into two groupings: Pleurocarp and Acrocarp.

(Below left): Pleurocarps grow capsules from a side branch. They usually grow in interwoven mats.

(Below right): Acrocarps have capsules at the tips of their branches. They grow erect and often cluster in tufts or cushions.

TYPES OF MOSS

Traditionally, mosses were classified in a group called the bryophytes along with the liverworts (or liver mosses) and hornworts (or foliage mosses). Nowadays taxonomists recognise these three types of plant as being quite different, and only the true mosses are called bryophytes. But in this book, and for the purposes of simplicity, 'moss' refers to the older bryophyte grouping, which includes the mosses, liverworts and hornworts.

Leaf moss (*Bryophyta*)

Leaf moss makes up three-quarters of Britain's stock of moss. Leaf mosses have a stem with leaves that are usually pointed and have a central thickening, known as a nerve,

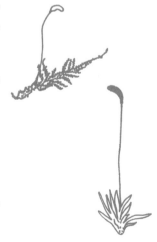

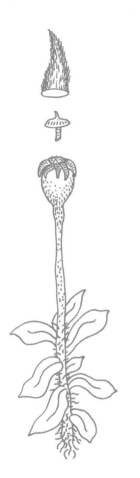

in the middle. They are curved in shape. The plant's structure is more complex than that of the liverworts, and some species have a protective cap over the spore capsule. Leaf mosses grow on all kinds of surface, from moist stones to dry heaths. They are usually subdivided into seven classes. One of these, the Bryopsida, or 'proper leaf mosses', is the class of leaf moss containing the most species. It is spread all over the world and comprises about 10,000 species, of which 1000 are found in the UK.

Liverworts or liver mosses (*Marchantiophyta*)

It is estimated that there are over 9,000 species of liverwort in the world, with just under 300 species growing in the UK. They consist of two groups: trunk liver moss and leaf liver moss. Trunk liver mosses are made up of a so-called trunk and have no stem and leaves. Leaf liver mosses, on the other hand, have stems and leaves that can be round or have two or more 'tabs' or lobes. They often grow alongside other moss varieties. The spores of leaf liver moss are small, black and egg-shaped. Liverworts are usually more sensitive to dehydration than leaf mosses. It is said that their name derived from the ancient medical theory of signatures, which held that plants that were similar in appearance to a particular organ in the body could cure diseases of the organ in question. In the Middle Ages, it was believed that mother plants (a plant that has given rise to new plants via spores) of trunk liver mosses could cure liver disease because of their liver-like form.

Hornworts or foliage mosses (*Anthocerotophyta*)

This is the smallest group of mosses, and of the around 400 hornwort, or foliage moss, species found in the world, most are found in tropical and subtropical areas. The spore-bearing generation has the shape of a needle and opens with cracks in its sides. They are rare in temperate regions because they are sensitive to frost, and in the

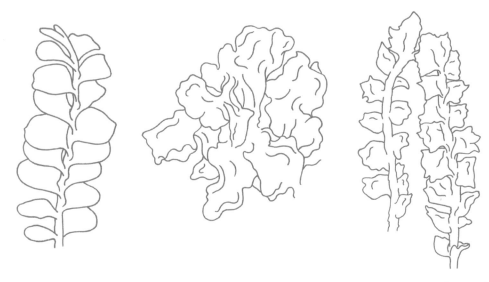

Most liverworts have leaves and grow erect.

A thalloid liverwort resembles a lobed liver in its shape.

Leafy liverworts have flattened stems with overlapping leaves in two or more ranks.

UK there are only a few species, including the Carolina hornwort and the smooth hornwort. Hornworts are very small, often between 1 and 5cm in size.

How does moss grow?

Moss can multiply both sexually and asexually (or vegetatively). Sexual reproduction involves the union of male sperm cells with a female egg cell. Sperm and egg may be from the same or a different plant. The spores that are produced are very light, and can travel long distances. Asexual reproduction doesn't require this fertilisation process to occur and produces identical offspring that remain very close to the parent plant.

Sexual development in moss consists of two phases. The first is the growth of the gametophyte. This is the scientific name for the green moss plant that we can see in nature and in our gardens. It is the visible part of the

The common name, hornwort, refers to the elongated horn-like structure, which is the sporophyte.

moss life cycle. When the gametophyte is mature, sperm from the male part of the same or a different moss plant travels to the female part of the plant, which is called the archegonium. The archegonium is flask-shaped, and contains water. The sperm must swim down the archegonium to reach the egg, or ovum. When sperm meets egg, fertilisation occurs. Because the sperm needs to swim to the egg, water is an important prerequisite for successful fertilisation; hence the need for mosses to occupy moist habitats.

With fertilisation, the second phase of the plant's life cycle begins: the growth of a sporophyte. One sporophyte consists of a stalk, a capsule and a lid or cap, and usually sits at the top of the gametophyte. The capsule matures to produce single cells called spores, which are released and travel through the air. If the spores land in a suitable location, they will grow into a new moss plant: a new gametophyte. Spores are very small and light, and can travel long distances with the help of insects, moisture or the wind. Therefore, moss species can colonise places far from the parent plant and thus spread across suitable habitats.

The asexual propagation is more local by nature. The spread is through special structures called gemmae, which usually grow from the leaves of the moss. Most of the time, they are simply a part of the plant, but they can break off to form new plants near the parent plant. Thus, asexual reproduction does not result in a sporophyte stage. There are no spores, and the new plant grows to be identical to the original plant. The gemmae are much bigger and heavier than spores so they cannot spread over large areas.

The spread of moss

Mosses are a widespread group of plants that live in a variety of environments. Mosses are vitally important to biodiversity. With knowledge of the ecology and planting sites of different mosses, one can learn where to expect each type of moss, which will help in determining where to search for specific species.

Mosses do not have the same nutritional needs as other plants, and therefore can live on surfaces where vascular plants have difficulty surviving. Such habitats include on stones, bark, soil and rock walls, as well as in caves, tundra, streams and wetlands. Some moss species may be the only plant growing in a particular place. Mosses have specific requirements for light intensity, humidity and nutrition. The acidity and moisture-retention properties of soil are both important, and the requirements of mosses vary between different species.

Mosses have the ability to establish themselves on a variety of surfaces. Some mosses are extremely discerning. For example, species like the dung moss (*Splachnum* spp.), grow only on dead animal remains or highly textured wood. Spruce moss (*Funaria hygrometrica*), grows well on old outdoor firepits, which have levels of magnesium and potassium that are so high that they would poison any vascular plant. Sphagnum (*Sphagnum* spp.), grow almost exclusively in marshes and in other very humid places where the water is not high in calcium (calcareous, chalky). Although the vast majority of mosses grow on land, there are some species that live in fresh water. Greater watermoss (*Fontinalis antipyretica*), grows in still and flowing water and is reminiscent of seaweed in appearance.

Mosses absorb water through their leaves, stems or trunks and are sensitive to pollution. Exhaust gases, heavy metals and microparticles in rainfall can be absorbed by mosses, which can result in them dying. However, some species can live in an urban environment. Most of us have probably seen moss in cracks in the pavement, on rooftops, in cemeteries, in tunnels or under the dirt on house walls. The reason why these species manage to grow in urban environments is that they are faster than others at reproducing and spreading. The more short-lived shoots they produce, the less pollution they are exposed to.

Is it a moss or not?

Mosses are sometimes confused with other plants, most commonly lichens. *Cladonia stellaris* and other sorts of reindeer lichen are often referred to as white moss, even among experts, and *Lobaria pulmonaria* and Iceland moss are often wrongly called lungwort or lung moss.

Mosses are usually green, although some species may be reddish, black or brown. A lichen is a composite organism consisting of a fungus and an alga that live in symbiosis. It is often grey, white, red or black; a few species are green but only in humid conditions. While most moss species have a clear division between stem and leaves, lichens often look as though they are 'printed' on the surface on which they reside, and look like coloured patches, brittle bushes or peeling paint. They also lack spore capsules.

Some green algae and red algae have also colonised land many times during evolution and have been mistaken for moss. *Chondrus crispus*, known as Irish moss, which was often collected for medical use in the past, is in fact an alga. Spanish moss (*Tillandsia usneoides*), belongs to the same plant family as the pineapple. Despite its popular name, it is neither a moss nor has any direct connection with Spain.

Practical uses of moss

Given how long mosses have been on Earth, it is not so strange that, like other plants, they have traditionally performed a functional use in human societies. In Scandinavia, parts of Alaska and northern Canada, glittering woodmoss (*Hylocomium splendens*), and red-stemmed feather-moss (*Pleurozium schreberi*), have been used as insulating materials in house walls and as seals around doors and windows. These two mosses are still used as sealants in the traditional construction of log houses. Water moss (*Fontinalis antipyretica*), also serves as a sealing material to plug empty spaces between walls in brick-built houses. Archaeologists

have also found that boats from the Bronze and Iron Ages were sealed with moss and, as late as the early nineteenth century in Scotland, moss was mixed with tar to prepare fishing boats for sea.

Polytrichum commune (common haircap) is often used in traditional crafts to make braid baskets, tassels, ropes and door mats. It is very strong; its leaves and shoots are removed to produce strong, bronze-coloured fibre threads. These threads can sometimes be up to 30cm long and are therefore suitable for different braids and bindings. Untreated *Polytrichum commune* has also been used as a covering and padding for mattresses. Even bears have re-alised the properties of this moss and use it to line their dens, hence the Swedish name 'bear moss' that they use for the species. In 1749, Carl Linnaeus, the scholar who for-malised binomial nomenclature, wrote about *Polytrichum*: 'The bear collects this for his winter collection of berries.' Linnaeus himself benefited from this particular species on one of his trips in Lapland. In his notes, he describes how he cut two pieces of bear moss into a mattress and a blanket and lay with the mossy sides against his body. Then, he claimed, he slept better than in the softest of beds.

Throughout history, particular species of moss have been used for medicinal purposes. Besides *Racomitrium*, which is used to make porridge by Native Americans and Inuits in Greenland, it is perhaps Sphagnum, 'peat moss', that has played the greatest role in curing vari-ous ailments. Peat moss (*Leucobrium* spp.), has wonderful absorptive and antibiotic properties, and for this reason compressed dried peat moss has traditionally been used to treat serious wounds.

This treatment method has not been limited to rural areas or domestic use. During the Russo–Japanese War (1904–5), peat moss compresses were used to treat injuries among soldiers and civilians. Peat moss is able to absorb fluid twenty times its own weight, and so it was an effective

way to stop bleeding without having to constantly change bandages. In addition, peat moss is black and so masked the blood from the soldiers' wounds, while also relieving pain with its antiseptic properties. This was of course an advantage in a war-hit environment where hygiene was inadequate.

During the First World War, several countries began to manufacture small compresses filled with sterilised and dried white moss. However, after the war, cotton compresses were preferred because they were white and gave an impression of hygiene. Despite this, the absorbent capacity of cotton is nowhere near as great as that of dried moss.

Dried peat moss has also been used by naturalists to protect the feet against cold, as nappies on toddlers, to cure skin conditions and as sanitary towels. In Chinese medicine, umbrella moss (*Rhodobryum giganteum*), is used as a cardiovascular medicine.

The practical use of moss today is modest. We tend to look at moss as something that belongs in the forest and must be fought against in lawns at all costs. In the UK especially, however, it has been discovered that moss creates an excellent soil or ground cover in orchards, with greater crop yields from trees when moss is used instead of grass.

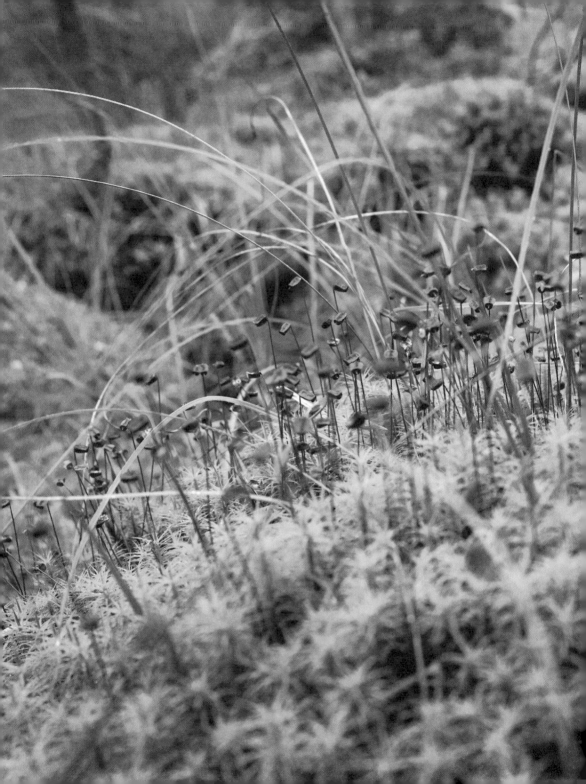

Moss in the field

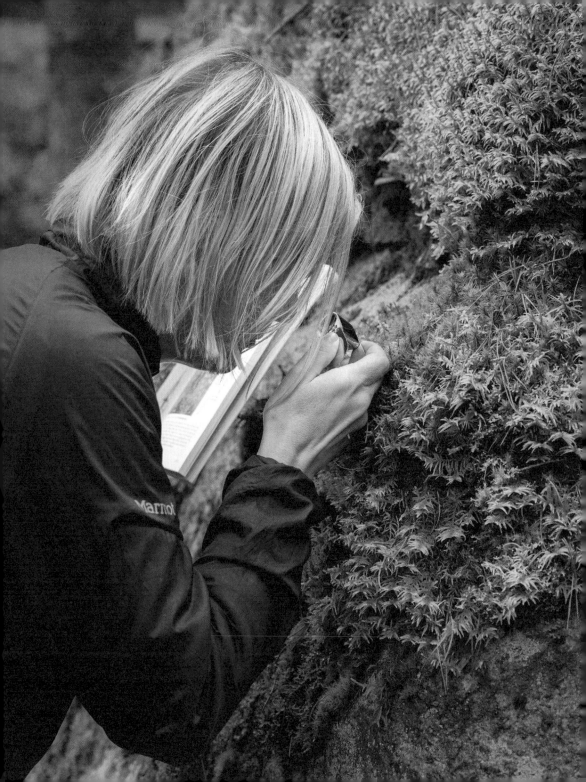

The most recent British moss flora describes about 800 species and new species are constantly being discovered. As soon as you start looking closer at mosses in their natural habitat, you will discover how multifaceted they are in colour, shape and variety.

Moss can be found and studied all year round. Autumn is the best season for moss-hunting as most species are well developed by then, which makes it easier to determine the species. However, the seasons should not limit you because most types can be studied all year round.

Equipment

In order to identify a species and see its detail in full, you ideally need a hand-held magnifying glass with ×10–20 magnifying power, a water spray bottle and an identification guide. A determination key, also known as an identification key, is a type of guide one can use when illustrations and images of a species are not enough. With a key, you can compare different features of a specimen and thus rule out certain families, relatives and species. There are some good field books and determination keys worth investigating. (See the Suggested reading section on page 181 for recommendations.)

If you want to collect a moss specimen, place it in a paper envelope and note down the name of the species, what type of plant it was picked from and the collection date. If you plan to determine the moss after a period of time, it does not matter if it dries out. Add moisture later to allow the moss to regain its shape and colour.

To improve your moss knowledge, you might consider joining a specialist moss tour or course. Many species have to be studied with microscopes and stereomicroscopes to be determined. The best way to study moss at a more advanced level is by joining study groups with other enthusiasts. (See Suggested reading.)

Identification

When studying mosses, it is important to remember that they can look different in dry and humid conditions. Different species may also have different colours and thicknesses depending on where they grow. Therefore, it may be helpful to look at several different examples to determine what kind of moss you are dealing with.

Take some well-developed pieces of moss, including some spore capsules, soak them in water using your spray and use a hand-held magnifier to look at the structure, colour and texture of the leaves. Then compare each piece with the other. Add drops of detergent to the water to help it penetrate the moss faster.

Often, several different species of moss can be found in the same area, and it is not uncommon for different species to grow on the same surface. Appearances may vary widely between the species found in one spot, but there may also be several closely related species that are very similar to each other.

Locations

Moss has the ability to grow in many types of environment – from forests to cities – and on a variety of different surfaces. So think creatively when looking for moss species. They can often be found in small and unexpected places: in small cracks between stones, old pieces of wood and concrete blocks, or on old, abandoned objects, such as bicycle racks or outdoor furniture. But the most obvious place to look for moss is, of course, in the forest.

Moss likes to grow on the bark of hardwood and softwood trees. Deciduous forests that shed their leaves annually usually have a soil pH level of between 5 and 6, which favours many moss species (although not all). Deciduous forests often have streams or water sources, making it possible for many different species of moss to

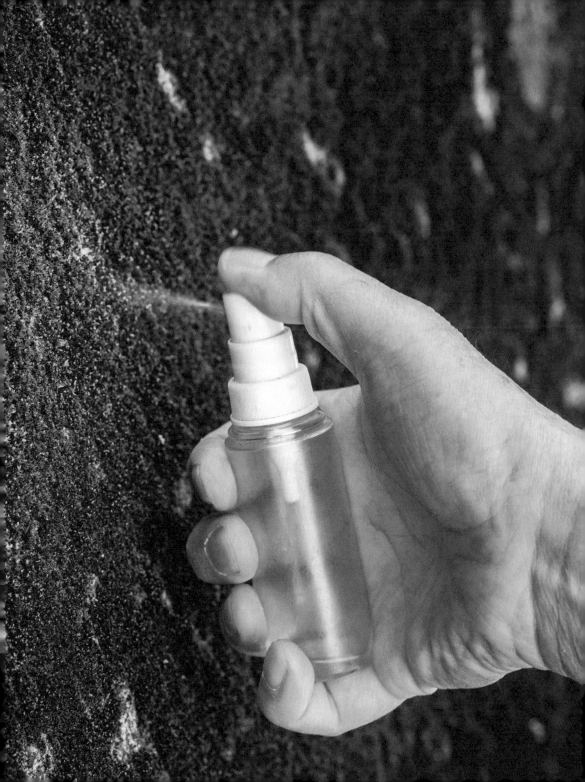

thrive. Some moss species especially like growing among the foliage of the trees. The structure, age, chemistry and moisture level of the bark, and its access to light, all affect the type of moss that grows on each tree.

In coniferous forests, the humidity remains relatively even, and rotten tree trunks and wood provide the perfect growing environment for moss. Often the trees in spruce forests are densely packed, growing close together, and have large crowns that provide cover for the ground below. This shade means that it takes a long time for the ground to dry out after rainfall, which is beneficial for the water-loving mosses.

Large carpets of moss can often be found on the floor of pine forests. The moss often covers rocks, like granite

and gneiss. Pine forests are drier and are more usually situated on sandier soils, so fewer moss species grow there. The mosses that do grow in pine forests tend to be species that can withstand drier conditions.

Some mosses can also be found in wetlands. There are various types of non-coastal wetland around the world, with two of the main ones being marshes – dominated by plants with leaves that float, like water lilies and duckweed – and bogs, which are waterlogged peatlands. Mosses such as *Sphagnum* are abundant in bogs.

Mosses that grow higher up in the wetland get their water from the rain and have a dense bottom mat, such as peat moss (of which *Sphagnum* is one kind), which dominates this type of vegetation. At the edge of moss mats, where the soil contains more nutrients, one can find bog haircap moss and some liverworts. In a marsh, certain parts will get some water that runs off from the connecting land. There are two types of marsh: those with a low pH value and those with a high pH. Different mosses can grow in each of these conditions.

How to pick moss

Sweden's Right to Public Access entitles all people to travel in the countryside, to temporarily stay there and, for example, to pick berries, mushrooms and some other plants. This right to access is subject to a consideration of nature, wildlife and landowners. Therefore, you should have the landowner's consent before you go out to collect moss. In the UK, it is illegal to uproot or dig up any wild moss without permission from the landowner or occupier.

The Swedish rubric of which plants you can pick is out of date and it must sometimes be interpreted with common sense. Mosses and lichens are not included in the legal text and may, therefore, be collected. However, they should not be collected in large quantities and for the purpose of selling. When you are on a moss hunt, it is important not to pick all the moss in one place, not to pick

batches that are too big, and to collect a few different species so as to destroy as little of nature as possible.

Bryophytes can be found almost anywhere, including on man-made objects such as buildings and cars, surfaces such as pavements and tarmac drives, and areas such as parks and fields. A wide variety of species can be found around houses and gardens. But the best places to look for bryophytes are sheltered and humid habitats such as woodlands, beside streams and in damp places such as bogs and fens.

Wildlife trusts have reserves that are excellent places to start. They usually do not mind people collecting small amounts of material for identification purposes, but in return they should be sent a list of species found. To find local wildlife trusts in Britain visit www.wildlifetrusts.org.

In Sweden, there are twelve free-standing moss species, and the shelter that they provide is important in habitats throughout the country. These species should not be picked or damaged. It is also important to know that there are some moss species that are red-listed, which means that they are in the International Union for Conservation of Nature's (IUCN's) list of endangered species (http://www.iucnredlist.org/). Check before picking a species that it is not endangered in the United Kingdom. (Learn more about how to gather moss on pages 115–17.)

A guide to some common moss species

The following is a description of various mosses that can be found when you are out and about. The type of habitat where you can find these species is given, as well as the type of substrate the moss prefers. Colour is an important identifier, and some distinguishing characteristics are also given to help identification. This list should not be used in place of a formal key, however (see Equipment, and Suggested reading). Note that some of the common names given here may relate not just to the species listed, but to the genus (the first of the two italic names). Likewise, some descriptions relate to the whole genus.

RED-STEMMED FEATHER-MOSS
Pleurozium schreberi

The leaves on *Pleurozium schreberi* are about 2–2.5mm long and oval. Their branches and red stems showing through translucent green leaves mean they are easy to recognise.

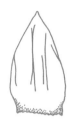

Red-stemmed feather-moss is a common moss that is easy to recognise due to its thick carpets and its gold-green colour. It often grows on stones in woods and easily breaks into larger pieces if it is lifted from the ground. The genus *Pleurozium* contains just this single species, although there is a similar species growing in the Andes that has been wrongly categorised in this genus. This and the Cypress-leaved plait-moss (see page 39) are used in environmental science to map heavy metals and toxins in Europe.

Typical plant environment: common in dry pine forests, but also grows in marshy forests and on hillsides.

Surface: grows on the ground and on rocks, masonry and wood.

Colour: green and gold-green or yellowish green. The stem is often reddish brown.

Characteristics: this is a large-growing species with green and yellow-green leaves that give a clear contrast to its red-brown stem. It spreads out in tight carpets with protruding feathery shoots that can be longer than 10cm. The leaves are close to each other on the stem and often have an oval shape with a blunt tip. Leaf edges often have small blunt teeth near the tip of the leaf and sometimes have 1- or 2mm-long spore capsules.

Distribution: Red-stemmed feather-moss is a widespread species, occurring in Europe, including throughout the Nordic region, and in Ethiopia, Asia, and North and South America.

Suitable for: kokedama, plant terraces, gardens with a lot of stone, roofs and insulation.

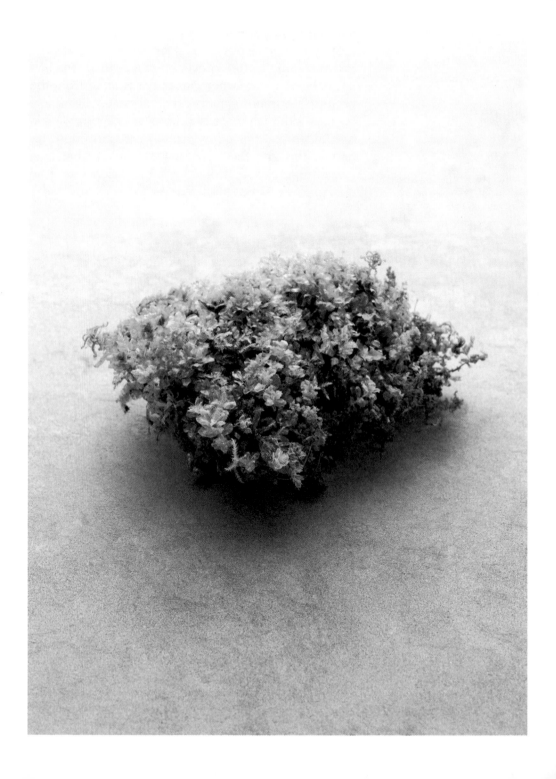

WOODSY THYME-MOSS

Plagiomnium cuspidatum

The leaves of *Plagiomnium cuspidatum* are 2.5–3.5mm long. The upper margins of the leaf are sharply toothed and the leaf base runs down to the stem.

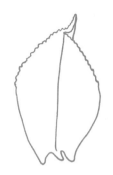

The genus *Plagiomnium* contains about twenty-five species, of which seven occur in Britain. The species like moist environments and are recognised by their oval and almost transparent leaves with clear nerves and large cells.

Typical plant environment: marshy forests, marshes and deciduous forests.

Surface: often on blocks or on the trunk of trees, mainly lowland. Likes to grow on nutrient- and mineral-rich substrates and near hardwoods, where it can absorb nutrition from seeds and leaves falling from the crowns of trees.

Colour: green to dark green.

Characteristics: the clear shoots can grow up to 5cm high and form dense carpets. The leaves usually have a clear, broad oval shape with clear tips and nerves. Leaf edges usually have sharp teeth from the tip to about the middle of the blade. Capsules are common and grow alone on fertile shoots.

Distribution: common in Denmark, Sweden, Finland and flatter parts of Norway and Iceland. Also found in parts of Africa, East and Central Asia, North America, Mexico and Cuba.

Suitable for: gardens and plant terraces.

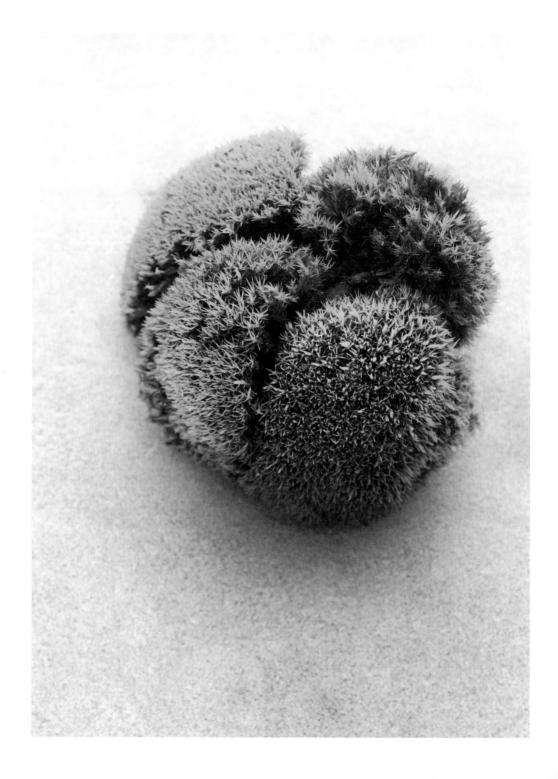

SEASIDE GRIMMIA
Schistidium maritimum

The leaves of *Schistidium maritimum* are about 2mm long and opaque. They lack a hair point. The unripe pale-green or ripe light-brown capsules, sheathed by slightly broader leaves, stick up slightly from the dense cushions. The capsule is almost completely hidden by leaves. It is reddish brown, cylindrical and broadest at the mouth.

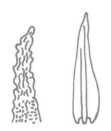

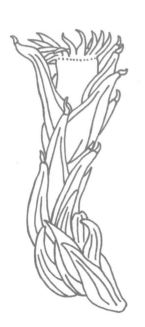

This genus, formerly called steel ring moss in Swedish, has very special capsules with short shanks and red teeth that form a flower-like wreath. The flower bulbs often grow in compact areas between or on rocks and in sunny environments. There are about sixty species in the world, and seventeen are known to occur in the British Isles. Of these, the seaside grimmia is one of the most common.

Typical plant environment: often found near streams and seawater, seaside grimmia is the only moss capable of living on rocks on the seashore, withstanding splashes of saltwater or brackish water that other mosses cannot tolerate.

Surface: all species grow on stones and rocks. They often settle on weak acidic and sun-exposed rocks and on slightly shady cliffs. Sometimes they can even be found on thin decks of mineral soil occurring on rocks near water sources. The salt blossom grows in cracks in both acidic and basic (alkaline) rocks, but not on limestone, and is never far from salty water.

Colour: green to brown.

Characteristics: soft texture on its dark green to brown tufts. The leaves are straight and stiff with a long narrow tip. The capsules are brownish and have the shape of a cylinder that is the widest at its mouth.

Distribution: occurs along northern Europe's coastlines and around the islands of North America and Asia.

Suitable for: gardens near water, plant terraces and as small outdoor plants on hypertufa or concrete.

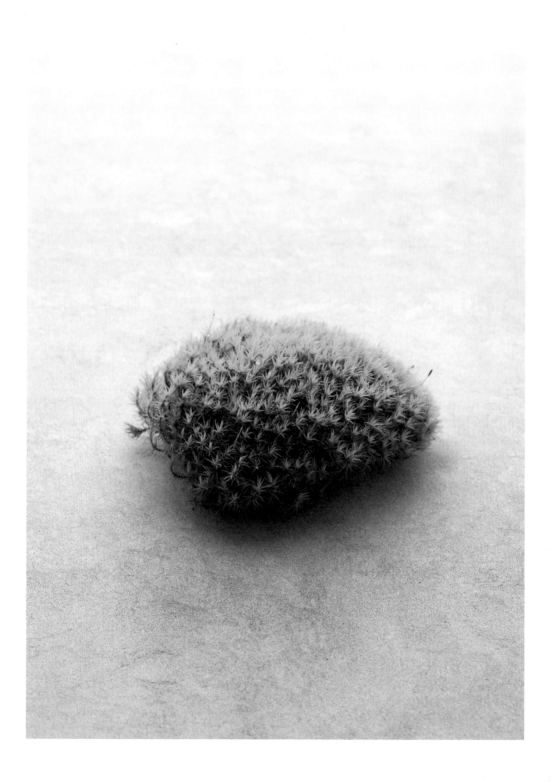

BROOM FORK-MOSS
Dicranum scoparium

There are about 100 different species of fork-moss. Some twenty-nine species are known in Europe, and broom fork-moss is the most common in the genus. Several species have leaves bent into an arc so that the tip of the shoot resembles a refuse bag. It is robust and coarse. Leaves are folded and curved to one side.

Typical plant environment: found in coniferous forests, but also in marshes and on mountainsides. It grows on soil, rocks, pebbles and tree trunks in both dry and humid environments.

Surface: both basic and acidic substrates in sunny and shady environments. Versatile.

Colour: green or yellowish green, rarely brown.

Characteristics: generates tufts about 10cm high. The back of the nerve has raised lines of cells which are just visible with a hand lens. The leaves are often straight, protruding and oval with a tapered tip.

Distribution: available throughout the country, even in the mountains.

Suitable for: gardens, plant terraces and larger moss plantations in barrels or in pots.

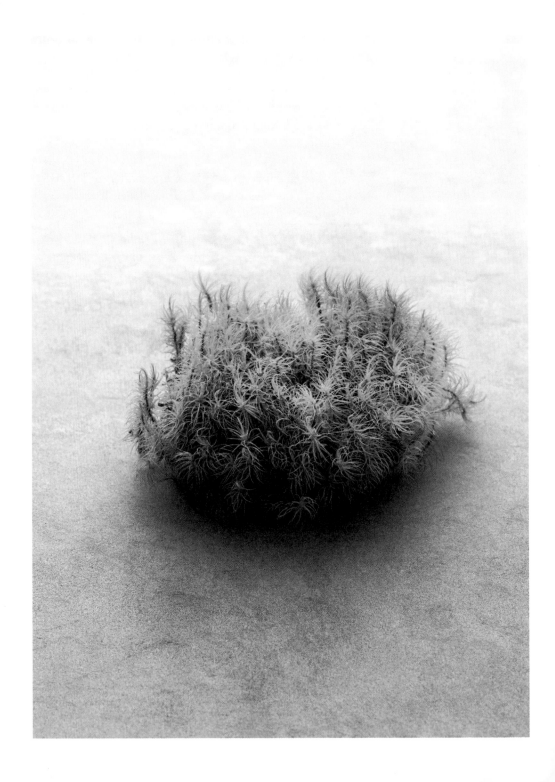

GREATER FORK-MOSS
Dicranum majus

As the name suggests, greater fork-moss differs from its cousin broom fork-moss in size. It often has unilateral curved leaves that can be just over 1cm long.

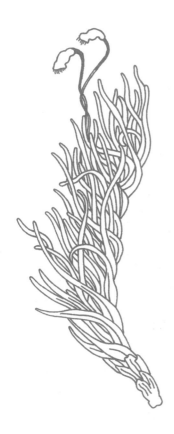

Typical plant environment: found in moist and wet coniferous forests throughout the country. In lowland areas, it often grows in shaded spots but in the mountains it is more exposed to light.

Surface: moist and wet soil, rocks and masonry wood.

Colour: light green to yellowish green.

Characteristics: grows in tufts that can be a few tens of centimetres high. The leaves are bent in curls from an oval base that ends in a narrow tip. It has toothed edges at the top of the blade. When they are poorly developed, they can sometimes resemble *Dicranum scoparium*.

Distribution: found in large parts of Europe, Asia and North America.

Suitable for: gardens and plant terraces. Good to plant in bigger troughs or pots.

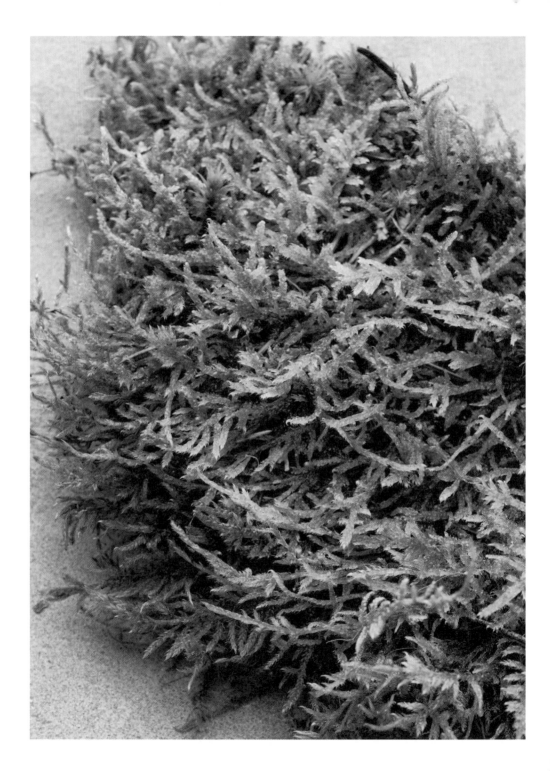

CYPRESS-LEAVED PLAIT-MOSS
Hypnum cupressiforme

Hypnum cupressiforme have 1–2mm-long strongly curved leaves that taper to a long, fine point. The nerve is absent, or very short and double. The shoots are green with a warm, brownish colour in the older parts.

This group consists of about eighty species around the world, including twenty in Europe. Characteristics of plait-moss include strongly curved leaves that end in a narrow tip and which are often wedged close to the surface on which the moss is growing, forming 'braids' or 'plaits'. Cypress-leaved plait-moss and the red-stemmed feather-moss (see page 29) are used in environmental science to map heavy metals and toxins in Europe.

Typical plant environment: forests, tree trunks and sea-shores.

Surface: grows on both limestone and on poor soil on the ground, and on stone and timber. Commonly found on rocks all over Britain.

Colour: pale-green to light-brown. The stem is either light-green or yellow.

Characteristics: creeps to form shiny green-yellow or light-brown carpets. This widespread and abundant moss has regularly branched, slender to medium-sized shoots typically about 2cm long, or strongly curved leaves, 1–2mm long, that taper to a point. Since the Cypress braid has a varied appearance, it can some-times be confused with other species in the genus of mud mosses.

Distribution: can be found all over the British Isles. Grows in large parts of the world but is unusual in the tropics, Arctic and Antarctica.

Suitable for: kokedama, plant terraces and for 'carpets' in gardens.

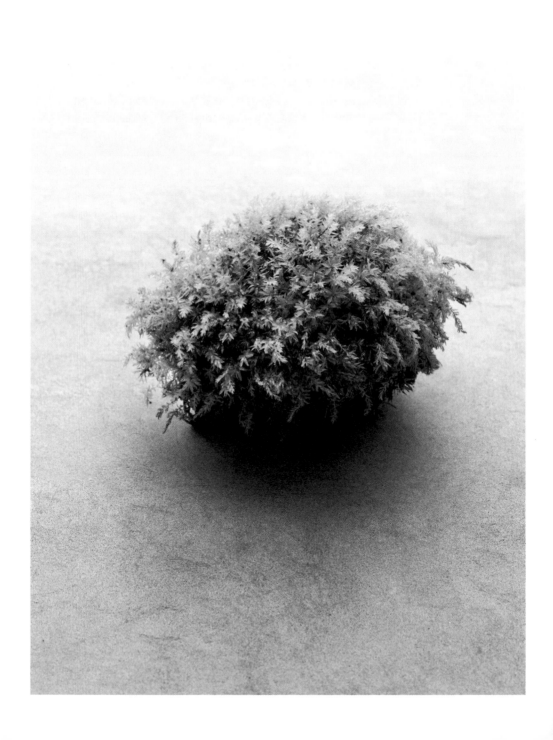

SWAN'S NECK THYME-MOSS
Mnium hornum

The upright stems on *Mnium hornum* are 2–4cm tall. Leaves are typically about 4mm long, but can be as long as 8mm towards the tip of the shoot. The lower part of the stem has small, narrowly triangular leaves. Capsules about 5mm-long are frequently produced.

This dark, dull-green moss is the commonest of the genus and one of Britain's commonest mosses. They often form loose green tufts which in time become reddish with gold-coloured elements. Swan's neck thyme-moss can sometimes be confused with the saw-mill *Atrichum* species.

Typical plant environment: on acidic soil, logs, rocks and tree bases, often abundant in woodland; mainly lowland, but also in rather early crevices among rocks on mountains.

Surface: the shadow star moss is the only species in the genus that does not like growing on a calcareous (that is, chalky) surface. It instead prefers low-pH surfaces, such as the bottoms of tree trunks and deadwood.

Colour: green to dark green but may change over time to reddish brown tones.

Characteristics: The upright stems are 2–4cm tall. Leaves are typically about 4mm long, but can be as long as 8mm towards the tip of the shoot, and have a toothed border of narrow cells. The nerve usually ends a little below the tip of the leaf. The leaf base runs down onto the stem. The leaf base runs down onto the stem. The lower part of the stem has small, narrow triangular leaves.

Distribution: often abundant in woodland; mainly lowland, but also amongst rocks on mountains in Great Britain.

Suitable for: garden or outdoor planting near water, or shady rocks.

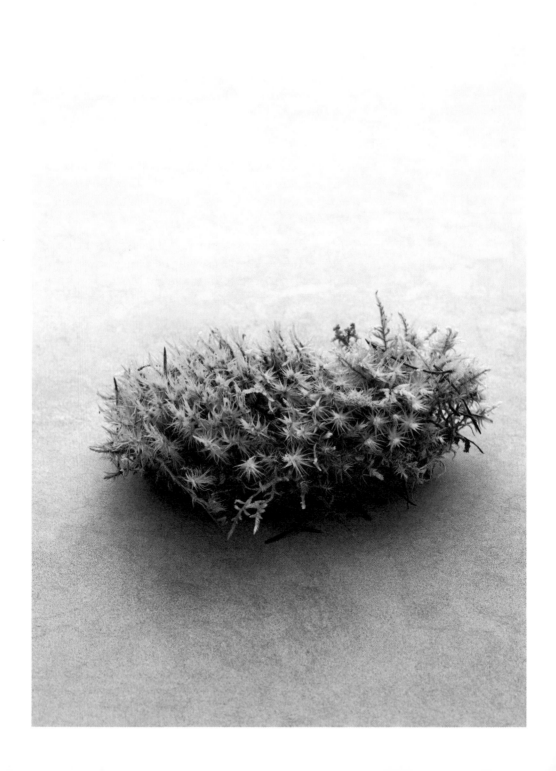

RUGOSE FORK-MOSS
Dicranum polysetum

Dicranum polysetum is a robust moss, forming patches up to 15cm tall. Approximately 7.5–10mm-long leaves are narrowly spearhead-shaped with the upper ones erect and curved. They are coarsely toothed some distance down from the tip. The nerve has two strongly toothed, raised lines of cells at the back. The stem is covered by dense rhizoids.

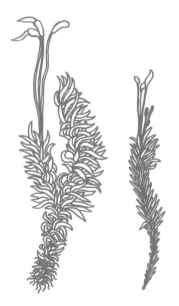

Rugose fork-moss is one of the most common species of the *Dicranum* genus. It can sometimes cover very large areas in pine forests and is relatively easy to recognise. It is found in large parts of North America, Asia and Europe.

Typical plant environment: grows in both dry and humid environments. Common in pine forests, hills, swamps and wherever trees grow.

Surface: earth, masonry wood and rocks.

Colour: pale green to yellowish green.

Characteristics: wide, wavy, protruding leaves with a pale-green colour. The leaves at the top of the trunk usually stand straight up while the leaves further down point straight out. A robust moss, forming open patches up to 15cm tall. The leaves are straight or curved with an oval base that tapers to a tip. Has sharp teeth from the tip of the blade rolled further down. The nerve is narrow, with two to four ridges, and ends just below the tip of the leaf.

Distribution: a lowland moss of the ground in coniferous woodland, but also occurring in birch woodland. A scarce species, but one which is apparently spreading slowly in Britain.

Suitable for: garden, planting and terraria.

SPRINGY TURF-MOSS
Rhytidiadelphus squarrosus

A grass-lover's enemy, springy turf-moss is the most common moss in lawns. It is common in Europe, Asia and North America.

The leaves suddenly bend to a long and narrow point, with a clear tip. (Below) A curved capsule. (Bottom) The shoots of turf-moss can be up to 15cm long. They are rigid and irregularly branched.

Typical plant environment: grows on all types of open, moist grassland in the lowlands.

Surface: nutrient-poor soil.

Colour: green, yellowish or brownish.

Characteristics: easy to recognise by its curved long leaf tips. The leaves usually cover the entire plant, which is green and irregularly branched. The broad leaf base completely sheathes the red stem so that it is only visible through the leaves.

Distribution: available throughout the country.

Suitable for: garden, plantation and terraces. Springy turf-moss is particularly good for widespread cultivation and spreads easily.

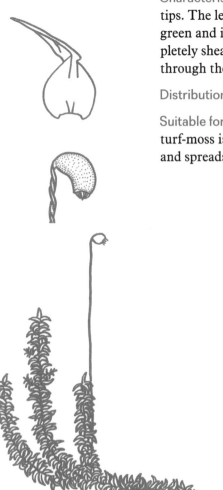

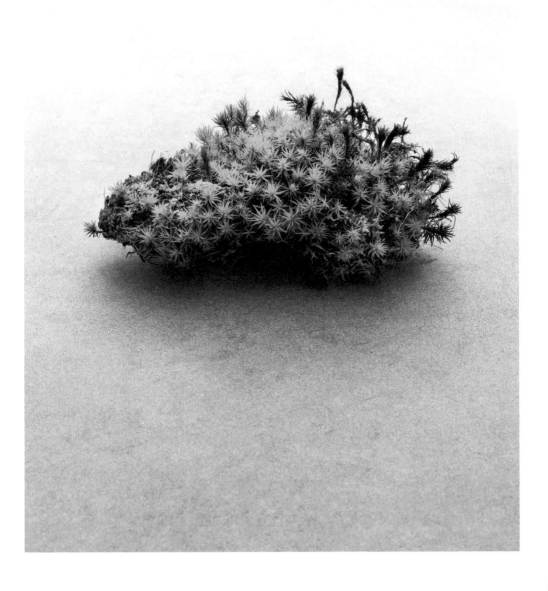

BANK HAIRCAP
Polytrichum formosum

A medium-sized moss that occurs in broad-leaved and coniferous forests. Common in Japanese and North American moss gardens. Grows also in Europe, North America and Asia.

Bank haircap can be up to 10cm high. The spore cap is pentagonal.

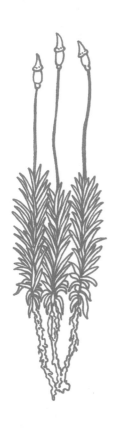

Typical plant environment: shady coniferous and deciduous forests.

Surface: on nutrient-rich hard surfaces such as rock shelves and rocky blocks.

Colour: dark green to red.

Characteristics: similar to larger mosses but often not taller than 10cm. The leaves are similar to those of a conifer and have the shape of stars around the stalk. Most often, pads are formed. The capsules are red and pentagonal.

Distribution: found throughout Britain.

Suitable for: gardens and mixed planting. Read more about how forest moss can be used in handicrafts in the Projects sections of the book.

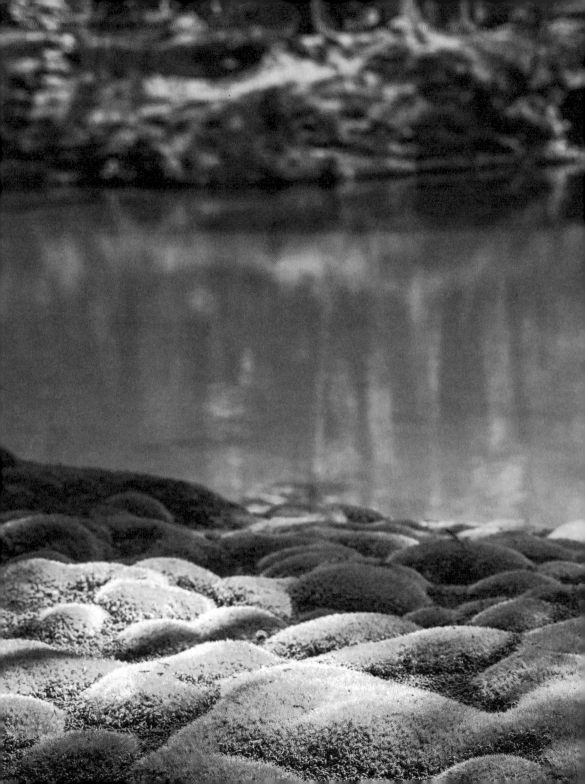

Around the world: gardens and gardeners

Anna Karin Reimerson
Handicrafter
Kölsta, Sweden

Anna Karin Reimerson, a retired homecare consultant, has a lifelong knowledge of the historical and practical uses of common haircap (*Polytrichum commune*). She has worked for Hemslöjden, the National Association of Swedish Handicraft Societies, a non-profit organisation that champions handicrafts, for over forty years and is a pioneer in natural handicrafts.

'When I was studying, we did not learn anything about these handicrafts. You were meant to create pieces that lasted for generations. It was only in the 1980s that I began to teach courses on how to use perishable materials like blackberries, moss and grass' said Anna Karin when she spoke to us at her house in Kölsta.

She lives in a red-timbered building and next to the house are beautiful broomsticks, garlands, wreaths and an almost finished carpet: all made of bear moss. They look genuinely crafted, like things from another time.

Even though common haircap is durable, its characteristics change when you start making things with it. Soft becomes crisp; green turns brown. When Anna Karin began to teach courses in handcrafting with common haircap, many would not accept that they could not keep their green soft mat for long. 'What's the point of spending so much time crafting if your work changes colour or does not look like it did in the beginning? The point of perishable material is the understanding that one can go out, pick it and then do something useful.'

Anna Karin is interested in how communities made crafts with materials from nature that were useful in everyday life. After the Industrial Revolution, though, the need to make one's own tools and belongings disappeared and the true purpose of such crafts was forgotten. Therefore, in modern times, there has been a lot of misunderstanding about the lifespan and function of perishable materials such as plants.

For example, many participants at Anna Karin's courses want to know how to water a moss doormat to keep it cool. 'But that's not the point, even though I do tell them that the moss will grow greener and puff up when it's wet. In an agrarian community, nobody had the time or the energy to water their doormat every day. The mats were used to wipe shoes on before entering cabin homes. The doormat was only used during the summer when the moss was still soft and functional. After that, they got rid of them. Making a common haircap doormat is not particularly complicated. Usually you use simple braid designs.'

Anna Karin likes practising craftwork with perishable materials because it is easy. For her, knowledge and history have always been more important than the act of creation itself. 'But I have to admit that it's fun to collect material from the forest. I have a landowner nearby who lets me pick as much moss as I want. And when you are playing with moss, there is nothing that says it should look a certain way without doing whatever you want. It is also quite amazing.'

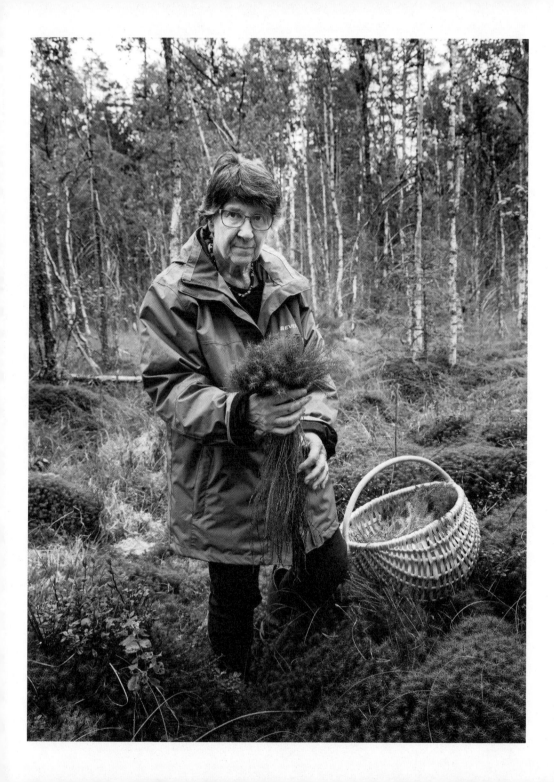

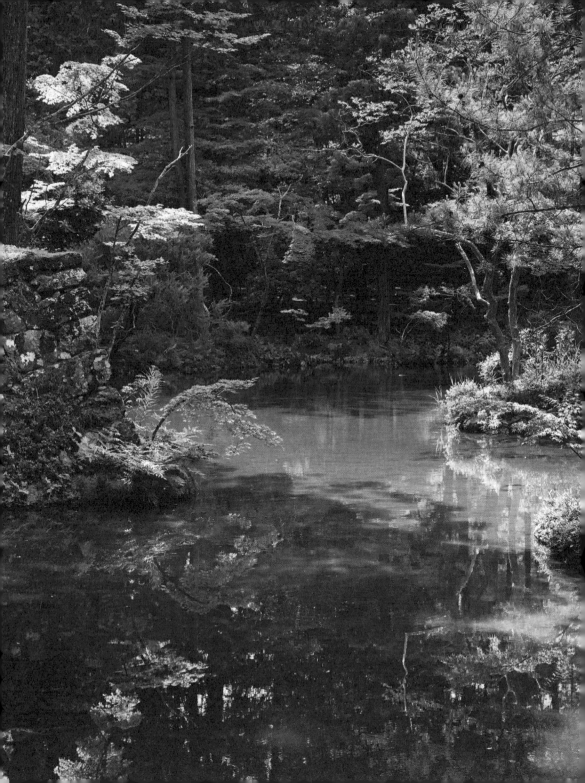

The peaceful simplicity

'Mosses in themselves are not holy plants. But when I look at them in a garden, I can experience the feeling of something holy. For us Japanese, mosses are special. They express silence, peace and time,' says Yoshitaka Oishi, professor at Fukui Prefectural University. Japanese garden culture is shaped by the climate and geographical location. Japan consists of four major islands and a total of 6848 smaller islands. Geologically, the country has been isolated from other countries by the Pacific Ocean. Many technical and cultural influences were imported from the mainland, often through China and Korea, but during the Edo period (1603–1868) Japan withdrew from the outside world and so it was a time when much of the native Japanese culture was formed. In Japanese garden art, one can see how the influences from, above all, China are often intertwined with Japan's own aesthetic and natural philosophical tradition.

The climate is also important to Japanese gardens and architecture. The northern part of the country has moderately hot summers, but long, cold winters with a lot of snow. Central Japan has hot, humid summers and moderate to short winters, and south-west Japan has a sub-tropical climate with long, hot, humid summers and mild winters. In general, however, the climate is very humid and in June and July it is the rainy season throughout most of the country. Creating a house with good ventilation is necessary because the summers are so moist and warm. Therefore, the traditional houses have a linear skeletal structure with large sliding doors and windows that allow the air to circulate easily through the rooms. Often, the walls and floors are made of wood because it is a material that swells and absorbs moisture. The floors were often built slightly above the ground so that moisture will not spread into the house from beneath. In a traditional house with an attached garden, the garden is

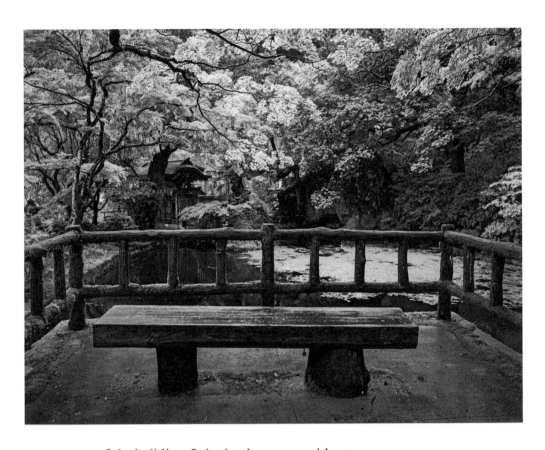

seen as part of the building. It is simply a room without
a roof. With the help of the sliding doors, the house can
be opened on to the garden, which becomes part of the
interior space and architecture. Architects and design-
ers also want the garden to be considered and seen from
within the house. It differs from Western gardens that are
often built and planned so that visitors will see and enter
the garden before reaching the house. This intimate rela-
tionship between architecture and garden design in Japan
is partly shaped by the climate in which it was created.
Even the highlighting of certain elements and plants in
the garden, such as moss, can be linked to the prevail-
ing climate. Without any doubt, the Japanese climate is

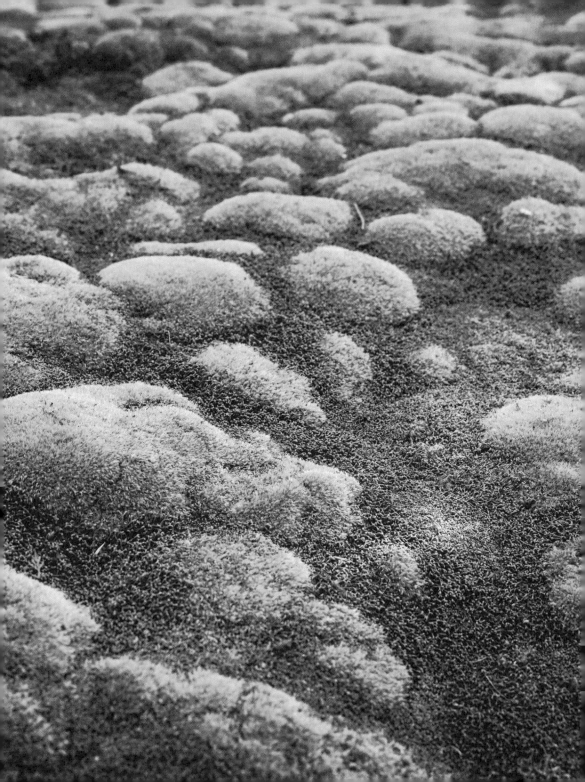

favourable to moss: more than 2500 different moss species are found there.

Nature, the garden and the divine

The close connection that the Japanese feel between humans and nature, and how this reflects in the garden, is well-known. It is true that the lives of the Japanese throughout history have been intertwined with nature in various ways. Japan's landscape consists mostly of mountains and forests, and the country is regularly affected by earthquakes and other natural disasters. The domestic religion, Shinto, which is a form of animism, revolves to a great extent around the cult of nature spirits, *Kami*. *Kami* is a complex concept, which can be translated as 'God' or 'divinities', but which often refers to the spirit or some kind of power or energy in nature. The whole of nature is therefore worthy of worship. It is full of spirits that may be benevolent if you are kind to them. *Kami* is said to be everywhere and especially in magnificent natural phenomena such as mountains and waterfalls. The most important *Kami* that is worshipped is the goddess of Amaterasu, the ruler of 'the plan of the high heaven'. The sacred mountain of Fuji is perhaps the most famous example of the presence of *Kami*.

However, there is a long tradition of different religions and philosophies practised side by side with Shinto, including Buddhism, Confucianism and Taoism, and it has resulted in different expressions, temples and symbols in the Japanese garden. Seen as early as the fifth century, Buddhism came to Japan with a strong Chinese influence. Then it was mainly Chinese and Korean craftspeople who built temples, palaces and gardens. The original word for temple in Japanese really meant 'forest' (*mori*), and the word for 'garden' (*niwa*) means a place where the Gods mass. The basic idea that the garden is a holy place differs from the Western tradition, where the garden is often a place of recreation and different types of activity. The

classical Italian Renaissance gardens were designed, for example, as places where people could meet and spend time with each other. Japanese gardens, on the other hand, have been places of meditation and thought. There, individuals can communicate with the Gods and understand that human life is a part of nature. From the Japanese Zen Buddhist philosophy emerged, among other things, *Wabi-sabi*, which was initially a doctrine that createed environments for reflection and meditation both indoors and outdoors. *Wabi* was a way of arranging stripped-back and simple environments for the ritual drinking enjoyed by the Japanese aristocrats in the fifteenth and sixteenth centuries. The word *sabi* was used initially to describe the naked beauty of poetry and can be translated as 'flowering of time' and represents the passage of time. Together, *Wabi-sabi* becomes a philosophy that illustrates a 'humble beauty'.

A common misconception in the West is that the Japanese garden is the same as nature. However, it is an abstract interpretation of nature that is clearly defined in contrast to the outside world. The separation often consists of a wall or hedge and gives an experience of depth and illusion in the garden. In Japan, nature has long been a link to the divine and to life. Without nature there is no life. The garden and the elements of nature contained therein, such as stones, plants and water, represent sheer beauty and are a way for the Japanese to be connected to the divine every day. That is also why religion has such a strong link with the garden in Japan. Many temple gardens have historically been used just for religious practice and learning. In Kyoto alone there are 1700 temples where the associated gardens show the traditional and multifaceted Japanese culture still living in the trees, the rocks and the moss.

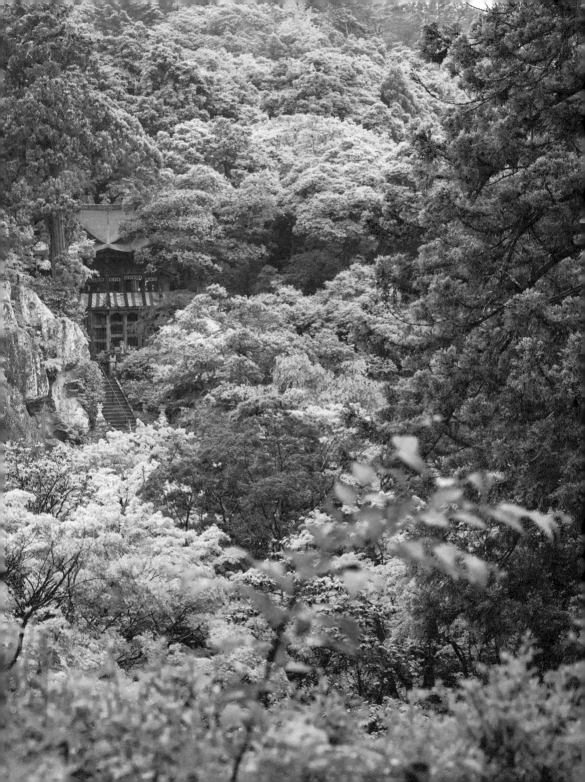

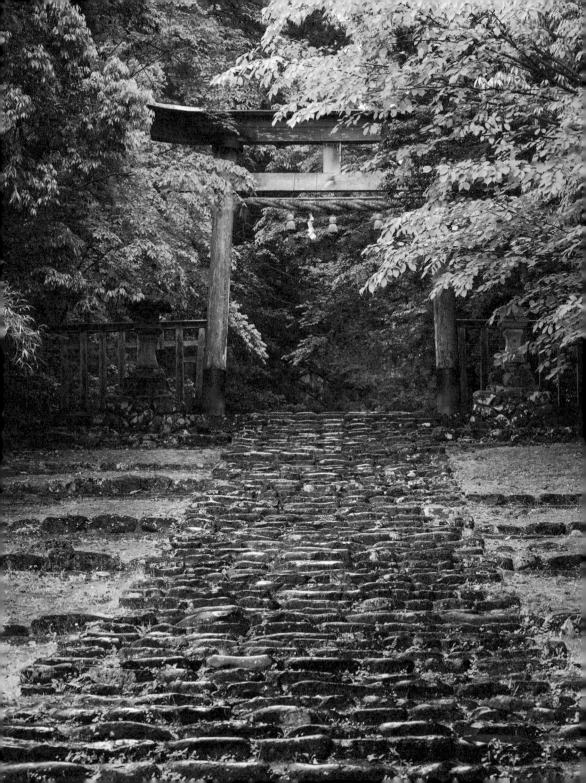

Walking in Japanese moss gardens

But what significance do mosses have and how did they become such an important element in Japanese garden art? Mosses actually established themselves in Japanese gardens in the same way as many other plants around the world have become garden favourites, by specimens growing accidentally from seeds and spores that are carried in by the wind, birds and animals. You can find references to moss in the classic Japanese poetry Waka, as well as in Zen Buddhist writings that are over a thousand years old. For the Zen Buddhist monks, mosses appear to have had a special meaning when they first appeared in their gardens. Mosses illustrated a peaceful simplicity and something lasting. And mosses have lived on in Japanese garden art and culture. There has been a significant increase in the amount of visitors who take inspiration from the temples to create moss gardens in their own homes. Hiking and nature walks have also become a popular hobby among both young and old Japanese who are interested in plants. Even classical gardens in Japan have elements of moss, and it is, of course, hard to say when a garden becomes a pure moss garden: it may be up to the viewer to decide.

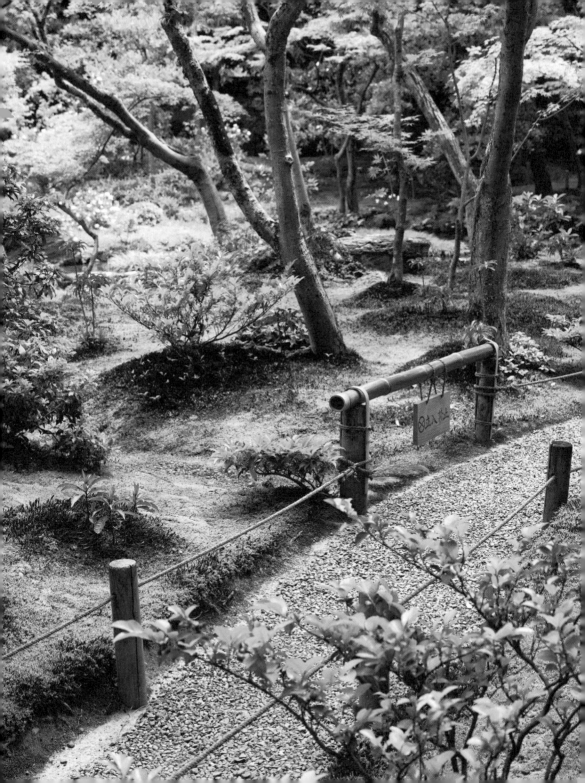

Murin-an
(無 鄰 菴: A Hermitage Without Neighbours)

A characteristic Japanese walkway where moss is an important feature can be found at Murin-an in eastern Kyoto. The house and garden were built between 1894 and 1896 by Yamagata Aritomo, Japan's third and ninth prime minister during the Meiji period. When Yamagata and gardener Ogawa Jihei VII planted the garden, Yamagata's wish was that the central point (*shuzan*) of the garden would allow many views of the Higashiyama Mountains, on which the garden is built.

This is a clear example of the technique known as *shakkei* in Japanese garden art, which could be described as 'borrowing an external landscape'. In creating Murin-an, *shakkei* was used to incorporate the surrounding hills and mountains into the garden, making it appear vaster and more spacious than it actually is. In 1901, the Emperor of Japan donated two pine trees to Murin-an, and a memorial stone commemorating this gift, Onshi Chisho-No-ki, was placed on the site. On the stone you can read one of Yamagata Aritomo's poems about the changing of the seasons. Based on this and other poems that Yamagata wrote about the landscape, Murin-an has been restored and maintained to reflect the way the garden originally looked.

In 1941, Murin-an was donated to Kyoto city and since then the house and the garden have been open to visitors. Murin-an is a relatively large garden with its 3135 square metres. As it has been 120 years since the garden was created, and the environment and climate have changed since then, the garden has not always looked the way it does today. In recent years, meticulous effort has been invested to maintain its original design. The shapes and pruning of the trees have been carefully managed to keep the mountain as the garden's central visual point and to hide the urban environment surrounding the garden,

Kyoto, Japan

without destroying its original proportions. The little meadow with wild flowers and long fragile grasses that Yamagata Aritomo enjoyed a great deal has also been preserved.

Murin-an cannot and should not be viewed in its entirely from any particular spot. There are pathways throughout the garden that sometimes divide into separate routes and areas where you can linger and lift your eyes and suddenly see a new aspect of the garden. Although every detail is deliberately shaped by human hands, nature is ever-present in the garden. Murin-an is located near Lake Biwa, and the water that flows into the garden's waterfall comes from that lake. In addition to its aesthetic features, the waterfall and the stream also provide a good environment for moss. Yamagata Aritomo preferred grass to moss, but moss eventually took over certain places in the garden, which he began to appreciate over time. Today, in Murin-an, there are about fifty different species of moss that are maintained with a great degree of conscientiousness. Bank haircap (*Polytrichum formosum*), grows near the waterfall and in the small forest in the garden. It thrives best under the trees.

There are many different species of moss growing in harmony throughout Murin-an. For example, in some places the strong, creeping moss *Hypnum plumaeforme* is removed to leave room for juniper haircap (*Polytrichum juniperinum*). There are also small areas of gold-red *Nardia assamica*, which is easily dislodged by heavy rain that flushes away both the moss and the top layer of soil.

To protect the ground surface and other moss species, Murin-an's gardeners mix plait-moss with *Nardia* to make it more resilient. Even the trees associated with some moss species are cut in different ways to meet their specific needs for light and moisture. Although Murin-an is not a pure moss garden, it is a unique example of traditional Japanese garden art and a cultivated environment that shows the simple beauty of moss.

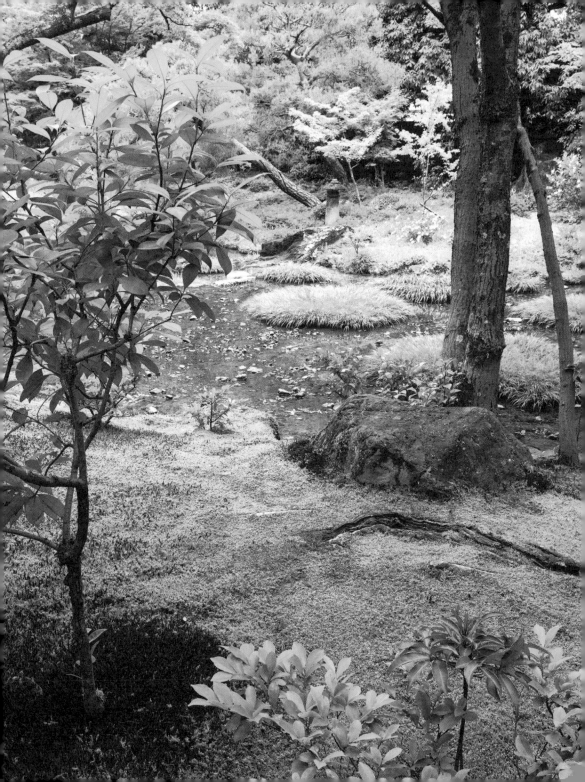

Tomoki Kato
Gardener
Kyoto, Japan

Someone who embodies the traditional Japanese gardener is Tomoki Kato. He is an eighth-generation gardener who works at the ancient garden company Ueyakato Landscape Co. in Kyoto, and has been learning the profession since childhood.

'I grew up with gardeners around me. My dad was a gardener, and at that time it was common for gardeners and their families to live together where they worked. We even ate all our meals together. Having gardens and knowing people who work in them has been natural to me.' We meet in Murin-an, the beautiful walk-in garden in Kyoto, for which he and his co-workers have been responsible for ten years. The garden is in the same area as Kato grew up. 'A goal with Murin-an has been to try to keep the garden similar to the original one. But to succeed in the cultivation of a garden, you must accept natural changes in the landscape, the changes of the seasons, and the impact of time on trees, plants and the surrounding environment. That's part of the process.'

Maybe that's why Tomoki Kato likes moss. He is another person we met in Japan who describes the connection between moss and time. 'The softness that moss adds to a garden is an important aesthetic element in traditional Japanese garden art. But there is also something else that we like to appreciate about moss. It is an abstract idea that is difficult to explain, but I think it has to do with the deep-rooted feeling we have for the passage of time. Moss takes time to grow and connect with the past.' In the 120-year-old Murin-an, grass almost dominated the entire garden, except for a small area around the house. It changed when moss settled in shady places in the garden. Today, grass and moss live side by side. The shadows from other plants affect which areas of the garden the mosses spread to.

Large trees give more shade, small trees less, so the mosses that can withstand more light usually grow in close proximity to them. It is always nature itself that determines which species are established in certain places.

'It is very rare that we influence what species grow in the garden, and even the care is quite limited. Certainly, we water mosses in the morning and evening during hot summers, and sweep away the leaves, but other than that we allow the mosses to take care of themselves. They decide which ways in the garden they want to go. That's what's fascinating. Mosses have something beyond beauty, which we simply cannot name and which I, as a gardener, cannot influence.' Moss's connection to nature and respect for it is something that Tomoki Kato returns to during our conversation. 'To have respect for nature is something that has been passed between generations of gardeners. In the oldest writing about gardening, *Sakuteiki*, there is a piece that says a gardener will never be able to create with his hands what mother nature can do over time. With the humility I feel in the face of nature, I also see moss.'

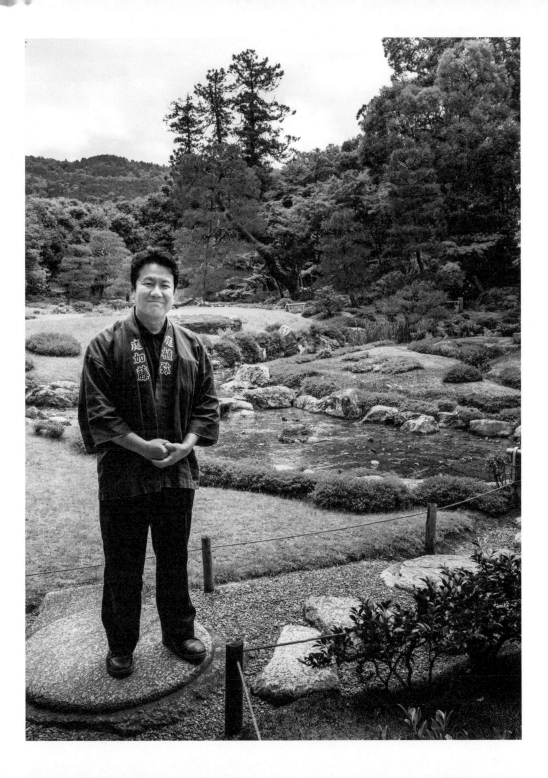

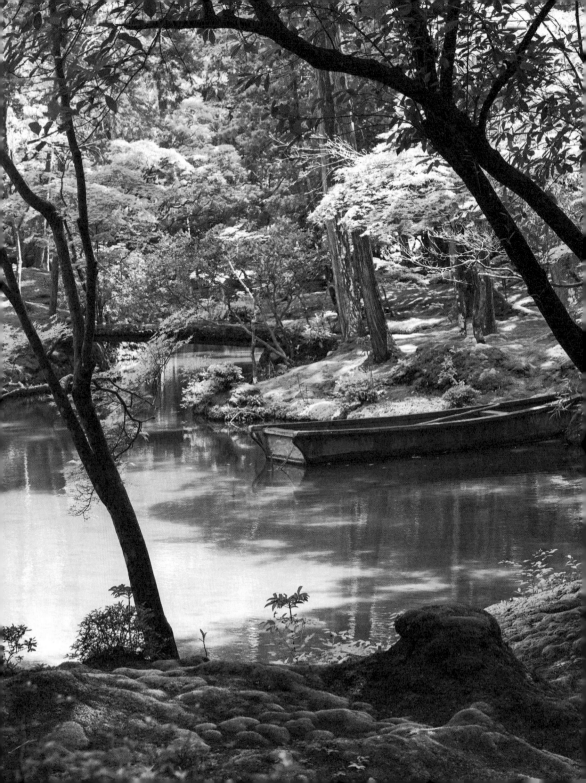

Saiho-ji (西芳寺)

Kyoto, Japan

The most magnificent and famous example of a moss garden derived from Zen Buddhism is Saiho-ji, also known as the Kokedera (or Moss Temple) in western Kyoto. Saiho-ji's garden is of great historical interest and also a particularly scenic place. The name refers to both the temple garden and the temple itself (*ji*). The temple and the garden were founded by the Buddhist priest Gyōki Busatsu and the temple was restored by Musō Soseki in 1339. However, during the Ōnin civil war from 1467 to 1477 Soseki's works were destroyed, and the moss that is now there was not part of his original garden design, most of which consisted of rocks. The mosses are said to have arisen naturally during the Meiji period (in Emperor Mutsuhito's reign of 1868–1912) when maintenance could not be afforded. The humid climate of the surrounding mountains of Kyoto was beneficial for the establishment of moss in the garden over time.

Throughout history, Saiho-ji has been an important place for healing and purification for different Buddhist communities, even though the garden is now best known for its impressive mossy coverage. Today, Saiho-ji features a circular walkway around a pond garden located in the eastern part of the temple area. The main pond is shaped like the Chinese character *kokoro* (心), which means heart. Although the shape of the garden has changed over time, it expresses a sense of tranquillity and dazzling beauty. There are 120 different types of moss that spread out like rolling quilts over the 18,000 square metres of the garden. The lower part has a pond containing three larger moss-covered and pine-shaped islands that form the 'islands of immortality'.

North-west of the large pond is a smaller water source with three rows of rocks that protrude above the surface of the water. These are called 'boats of stones that add at night'. The rows of stones represent boats containing

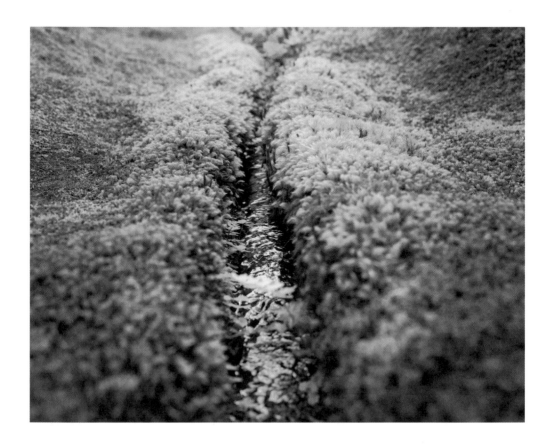

pilgrims sailing to the holy mountain Horai to look for treasures and the source of immortality. In the garden there is also a dry waterfall (*kare taki*), an arrangement of stone blocks that 'falls' down the slopes of the garden. There is no water; instead, the rocks represent the composition of the waterfall and the power of silence and eternity sailing to the holy mountain Horai. The rocks are nevertheless arranged in such a way that heavy rain can transform the waterfall into life. Saiho-ji's dry waterfall is an important form of gardening, as it is an example of how to use stone in a symbolic way to recreate nature in Eastern garden culture. This dry waterfall is said to be one of the first preserved examples of dry stone landscapes (*kare san sui*) in Japanese garden art.

Despite the natural impression that the garden gives, it is tended very carefully. Much time is spent on maintenance, and visitors can see garden workers every day removing leaves, branches and twigs from the moss with their bamboo broomsticks. Going through the garden is like weaving through a soft felt of different tones of green, gold and bronze. Different species of moss live side by side but many species that have been there since the beginning have disappeared as a result of changes in the environment. Some of the most widespread mosses in the garden today are haircap (*Polytrichum*), blue moss (*Leucobryum*), mnium thyme-moss (*Mnium*) and larger/smaller white-moss (*Plagiomnium*).

Each species has found the place in the garden that best fits it. For example, the pale-green pillows of *Leucobryum* are best in the shade of the tree crown, and *Polytrichum*, with its clear green colour, grows better in sunny spots. With changes in the climate some species also swap places with each other. These genera are also very common in other moss gardens. In particular, haircap (*Polytrichum commune*), is appreciated by gardeners because it can withstand sunlight well.

Until 1977, Saiho-ji was completely open to the public, but the large number of visitors led to the provision that tourists must apply in advance to have access to the temple and gardens. The same rule still applies and is said to have been introduced to protect the moss from the busloads of people who came every day. Saiho-ji is one of Kyoto's UNESCO World Heritage Sites.

Hisako Fujii
Author of *Moss, My Dear Friends*
Kobe, Japan

Hisako Fujii was working as an editor of cookbooks in a publishing house when she entered the world of moss more than fourteen years ago. 'It was a job with high pressure and stress. One day, I realised that I had to take a break and decided to go on holiday to the Yakushima National Park on Kyushu Island. There I went with some others on a moss walk. The moss had spread everywhere. On rocks, on trees and on the ground. The whole forest was dressed in a bright green soft coat. It was like finding a treasure from another time.' From that day, it has been a passion for Fujii to learn more about moss. She started searching for, collecting and drawing moss in the areas neighbouring Tokyo: she studied botany, read books, met groups that organised moss walks and viewed herbarium materials. In 2011, her first book, *Moss, my dear friends*, came out. The book describes fifty different moss species with text and drawings, and is aimed at people without any prior knowledge of moss. It became a sales success: it has been reprinted five times and is said to be one of the reasons why moss walks have become a hugely popular hobby among young people in Japan. When people began to go to different forests to study moss, their knowledge about these plants also increased. This made Hisako Fujii decide to write a sequel to the book at a more advanced level. *A Field Guide to the Mosses of Japan*, published in 2017, describes 182 different moss species that are found not only in forests but also in gardens, temples and urban environments.

'In my second book, it was also important for me to write about nature conservation and how we should behave in the forest and the impressions we leave behind. I see it as my task to inform others about how amazing mosses are, but also about the shared responsibility we have for preserving nature.' Hisako Fujii lives in Kobe, where she grew up, and is close to the nature around her. Despite the fact that she has accumulated so much knowledge over the years, her interest in moss has not waned. 'Mosses are so interesting because there are so many different species and it's always exciting to watch them close up. Just like the seasons, mosses pass through stages and change their appearance each season. There is always something new to discover.'

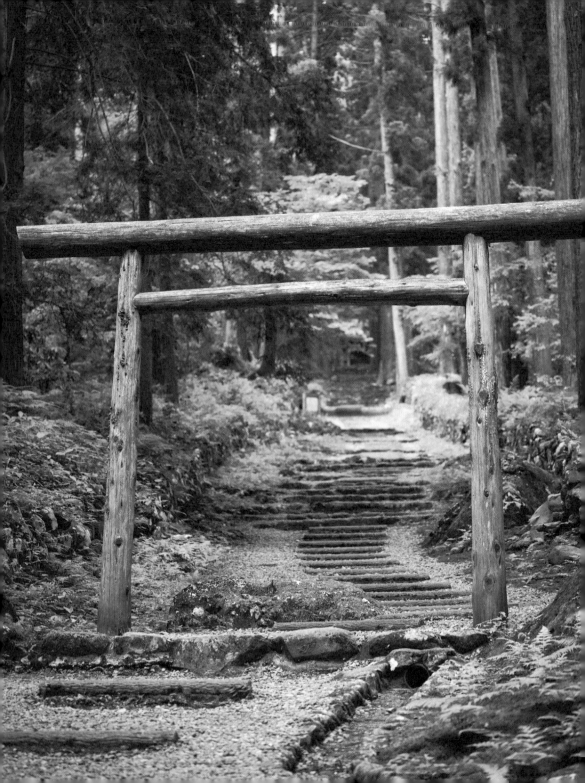

Heisen-ji Hakusan Shrine
(平泉 寺 白山 神社; Hiraizumi Temple Hakusan Shrine)

Fukui, Japan

Heisen-ji Hakusan Shrine is another magnificent and attractive garden in Japan. The temple area is located at the foot of the Sacred Mountain in the Hakusan Nature Reserve in the Fukui Prefecture on Honshu's west coast. Here, mosses have grown for over 1300 years. The temple was founded by the monk Taicho Daishi in 717, and until the Middle Ages had a strong religious attachment for practitioners of the Shugendo religion, an ancient traditional esoteric Buddhist sect. It was once the site of a city that had forty-eight shrines and thirty-six temples, but they were mostly destroyed in the sixteenth century. Heisen-ji Hakusan is today filled with silence, clean air and moss covering everything from trees and stones to gravel on the ground.

The mosses change in colour from green to brown and lie like soft mattresses around the majestic Japanese cedar trees (*Cryptomeria japonica*), also known as *cryptomeria* or *sugi*.

In Heisen-ji Hakusan there is also a more than 400-year-old garden with its own entrance. It was originally a sandy yard, but the moss enveloped it over time. The garden is maintained, but with gentle hands. In Heisen-ji Hakusan, the aesthetic concept of *Wabi-sabi* is visible, which is about accepting the garden as transient, temporary and incomplete. The varying green colours of mosses next to each other also provide an aesthetic structure that is perceived to be an example of *Wabi-sabi*. It leads one to appreciate the integrity of natural objects and processes. By accepting the 'integrity' of the mosses and trees, allowing them to settle over time, one is able to connect the present with the time before Heisen-ji Hakusan was destroyed in the mid-1500s.

About 150 different species of moss grow in Heisen-ji Hakusan. The number of species is slightly more than

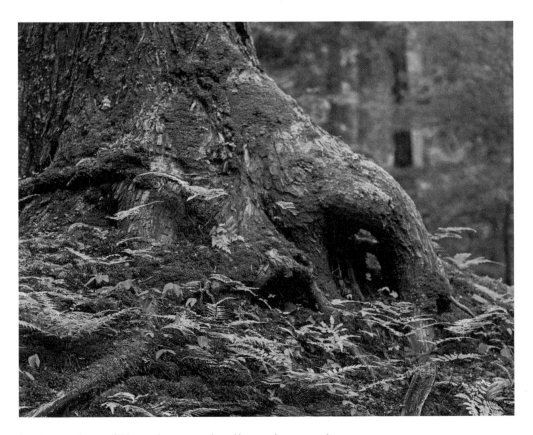

in the gardens of Kyoto because the climate is somewhat cooler. During the mild winters, it snows in the region. The snow creates a protective covering which, when it melts, gives both moss and soil the favourable moisture they need. The most commonly observed species here are hinoki-goke, (*Pyrrhobryum dozyanum*), a species that is specific to Japan, smaller white-moss, (*Leucobryum juniperoideum*) and *Hypnum formianum*.

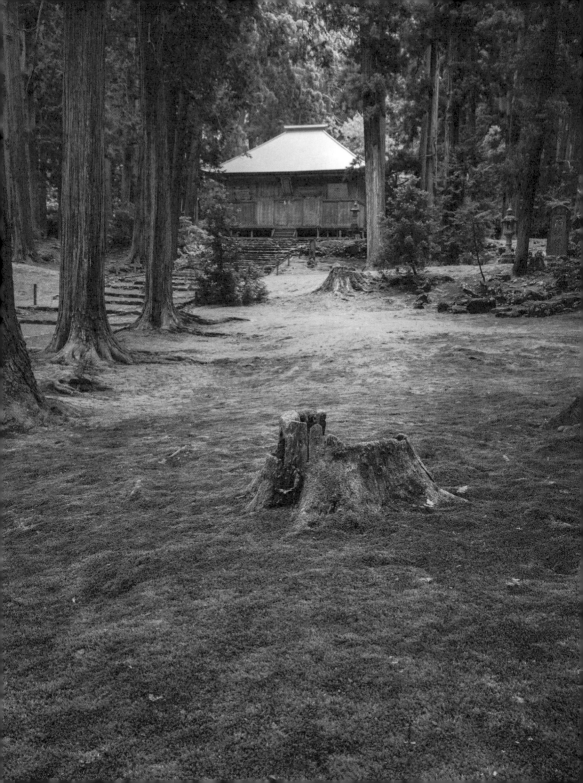

Yoshitaka Oishi
Moss researcher
Fukui, Japan

'Yes, why *is* moss so important to us? We experience it as something beautiful and special. It is a symbol of something long-lasting that connects with previous generations and places. The Japanese tradition *Wabi-sabi* has also played a role in its important position here. For example, different species of moss grow next to each other with different colours of green and structures and *Wabi-sabi*. It's finer than just one structure and colour.' Yoshitaka Oishi is a teacher and one of Japan's most prominent moss scientists.

He works at Fukui Prefectural University and is also adviser to some of Kyoto's largest gardens. He is primarily interested in the importance of mosses for the ecosystem and how they develop and function in changing environments. Moss can tell us a lot about both pollutants in the air and changes in the climate.

'A challenge facing many gardens in Japan today is how the plants are affected by the climate and environmental changes. In particular, gardens located in cities, like Kyoto, must find new methods of cultivation if certain species are to survive.' When Yoshitaka Oishi began researching moss in the early 2000s, he was relatively lonely in his chosen field of science. Interest is much greater today. Several hundred students a year are studying moss ecology.

'Making your own moss terrarium and going on moss excursions has become popular among many young people. With today's technology, high-quality images can be captured, making it easier to document and share their discoveries. Today you see moss in a different way than ten years ago. That's a positive development.'

It was his interest in ecology that persuaded him to begin studying just moss. He became fascinated by how the species vary and also how they change character depending on what environment and what part of the country they grow in. 'Mosses are very beautiful as well. Looking at mosses that grow around a stately cedar tree or sharp stones is something special. They provide a gentle and almost meditative impression that almost no other plants can.'

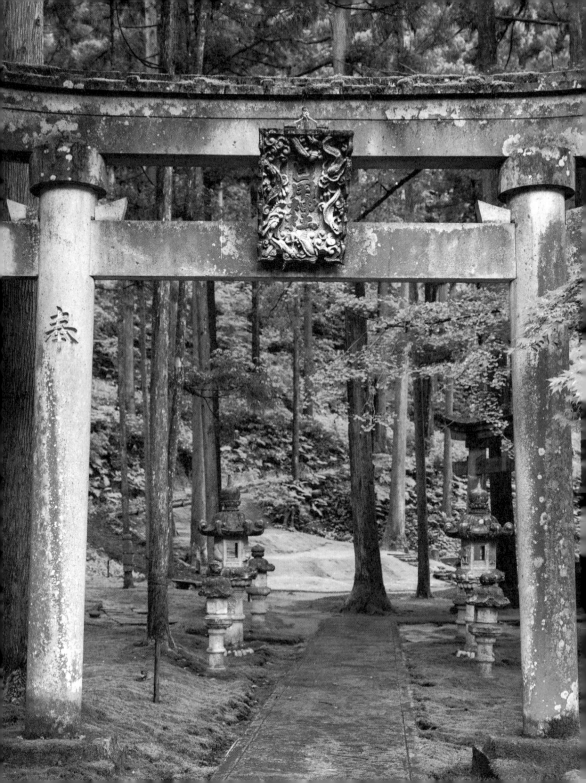

Forest of Wisdom (叡智の杜)

Komatsu, Japan

Outside the town of Komatsu in Ishikawa Prefecture on the Japanese Sea, not far from the Hakusan mountain, lies the village of Hiyou. Here, around some residential buildings, is the magnificent moss garden known as the Forest of Wisdom. The private garden is 200 years old and was originally a single large garden, but when a small road was built through the village in the late 1990s, it was divided into two, and today there is one garden on either side of the road. From the outset, the original garden and its environs were not considered to be anything special because they were badly maintained and in poor condition. But when a professor from the United Nations University in Tokyo visited the area for an environmental inspection, he was so taken by the moss and the trees in the place that he gave the garden the name Forest of Wisdom. Then the villagers understood what a unique place they lived in and started working with the garden, and since 2012 the garden has been open to the public.

The mosses have always existed here, and nothing has really changed in the shape of the garden except for some traditional stone aisles that were added when the garden was opened to visitors. A number of years ago, sand was used to create hills that you can now walk around to see the moss from different aspects and directions. The place where the garden is located is very favourable for moss all year round as it has high humidity for *Cryptomeria japonica*'s shadowy dense crowns. In the garden there are about forty-eight different species of moss, including hinoki-goke (*Pyrrhobryum dozyanum*) and juniper haircap (*Polytrichum juniperinum*), which are very widespread.

To ensure that certain moss species flourish, they are grown from spores. Dried spores are spread out in plastic boxes filled with muddy sand and placed under the ideal level of lighting that the species prefers. The sand

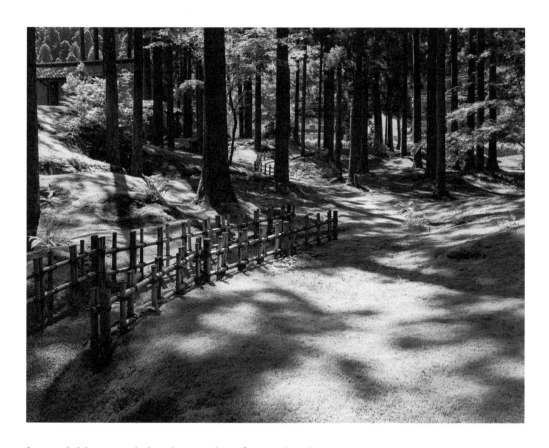

is special because it has been taken from a local mountainside where the pH levels are just right for mosses to flourish. Then they are allowed to grow. Watering takes place daily and after about two years the moss will have grown into a dense mat that can be moved into the garden.

Cultivation is on a small scale because the vast majority of species found in the garden spread naturally. During the winter the garden is closed because too much snow falls, but from early spring to late autumn the villagers maintain the garden collectively, which mainly consists of sweeping away the coniferous cryptomeria that falls on the moss during the spring.

The finest thing about the Forest of Wisdom, in addition to the almost surreal shades of green of the moss,

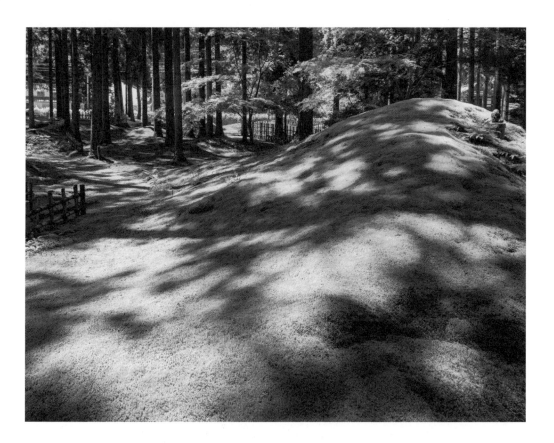

is its location. There is something special about a moss garden that is located in a forest where the birds are chirping, you can hear the sound of a distant stream in the hinterland and where you cannot really decide where the garden starts and the landscape ends.

Uchino Nobuaki
Moss artist
Takarazuka, Japan

It's easy to see that Uchino Nobuaki belongs to a generation that has grown up with social media. When we meet him and his wife in their home outside Kobe, he is hardly surprised that his Instagram account just passed 39,000 followers. However, there is no other social media personality like Uchino. The pictures he publishes on his account show lamps in glass that contain almost unreal green moss landscapes. If you could, you would like to step right into these brilliant worlds.

'As a professional, I worked with lighting. Four years ago, I began to plant small bonsai trees in glass with LED lighting. I also planted moss in some of them. It worked so well that I eventually left the trees, to focus only on creating light that promoted the growth of moss.' He was asked to attend an exhibition with his lamps in a tunnel going through Mount Rokko outside Kobe. The response was enormously positive. Afterwards he realised that it was the mosses themselves and not the lights that the visitors had been so taken by. 'Then I was really interested in learning more. I started collaborating with a biologist and eventually began to conduct guided moss walks.' The moss lamps (see page 136) are a natural science and artistic project.

Uchino does not sell his work but participates only in exhibitions aimed at increasing the public interest in moss. He hopes that people can discover the species that are unique to the geographical area in which they live. But despite the fact that Uchino is not interested in turning his lamps into a commercial product, he has at least found out what kind of light and environment are required for moss to thrive indoors. 'I simply went out into the woods and measured the natural light conditions for a certain species of moss and found that most species need about 1235 lux to enjoy it [lux is a measure of the intensity of a light source]. Based on that, I created a light that has the same lux and colour value as the environment outdoors.'

Uchino uses about twenty species of moss in his lamps. The most common is *Racomitrium japonicum*. To plant a landscape, he first puts a layer of sand he collected near a mountain in the bottom of the glass. Then he covers that with ordinary aquarium sand, lays out a stone or piece of moist wood, and then sows the spores or spreads out small pieces of moss. Finally he applies water and lights the moss with a lamp that stays on during the day and turns off at night. Then he has to wait. After about three to six months the moss will have begun to spread under the glass.

Even though the lamps are so popular, they seem to have secondary importance to Uchino. 'To do this is based on my willingness to be in nature and to understand and relate to it. The best is still when I see my favourite moss, *Pyrrhobryum dozyanum*, in nature. Sometimes when I look at the soft folds for a long time, I think it looks like little animals lost in a cat-and-rat game.'

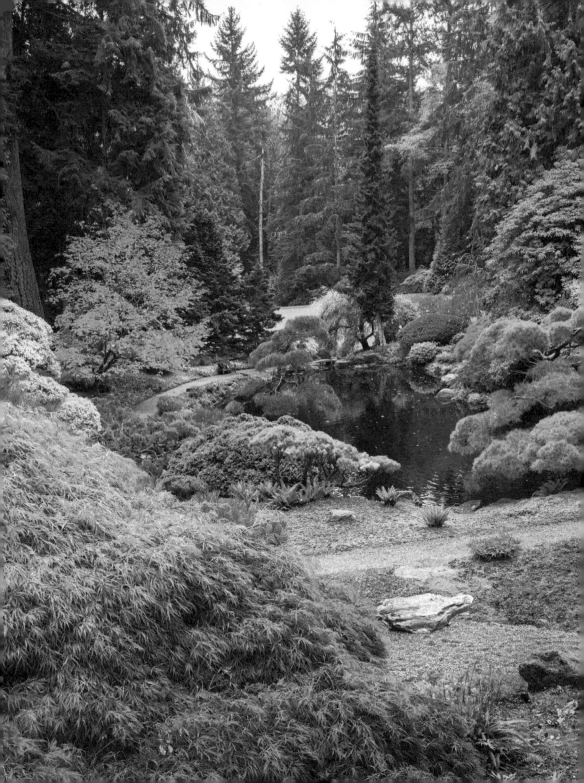

Moss gardens in the UK and United States

If you are looking for moss gardens open to visitors outside of Japan, you will find some excellent examples on the other side of the Pacific Ocean, in the north-western part of the United States. The fact that several moss gardens are there is perhaps not that strange because the climate around the coast is temperate, with mild, rainy winters and warm, dry summers. There are also many Americans of Japanese origin who have influenced the local horticulture and garden culture.

We visited two gardens in Portland and Seattle where the mosses have such a clear place that it is difficult to understand that you are actually in the United States and not in Japan. However, these are two gardens of completely different character. Portland Japanese Garden is a classic Japanese garden where the mosses are part of the entire garden's philosophy and composition. Bloedel Reserve, on the other hand, is a natural garden where the mosses illustrate the local flora, the environment and the climate. Moss gardens open to the public are still unusual in the West, making these two gardens unique in many ways.

Today there aren't any proper moss gardens open to the public in the UK, but we found a private garden in the Lake District, Cumbria, where moss plays the leading role. The climate in the UK being ideal for moss, Windy Hall might serve as an inspiration for your own moss garden creations.

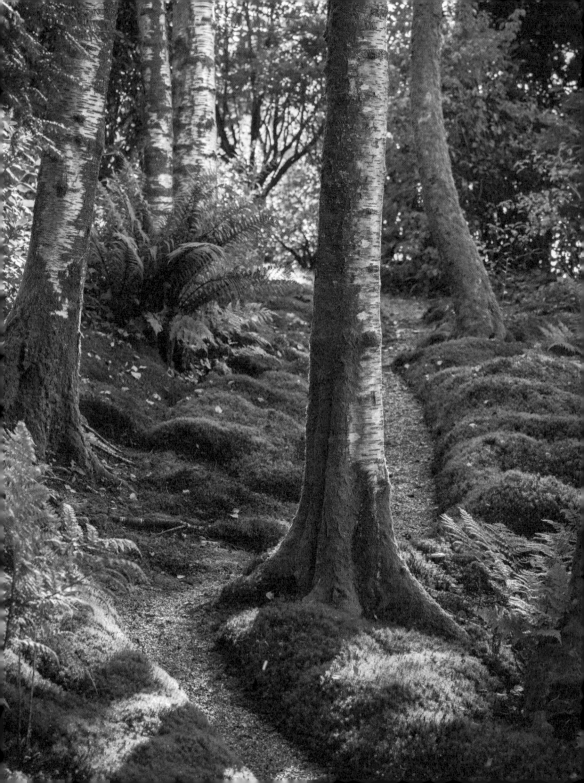

Windy Hall (Windermere, Cumbria)

Cumbria, UK

It was while commuting in 1981 that Diane Hewitt and her husband David Kinsman first spotted Windy Hall, a row of seventeenth-century cottages on the hillside above Bowness-on-Windermere in the southern part of the Lake District, Cumbria. They had talked about owning a place where they could do gardening, have some ducks and a flock of sheep. Windy Hall, being close to their work as research scientists at the Freshwater Biological Association in Windermere, would shorten their commute and add hours to their day that could be spent doing more interesting things.'We came here to garden, and that is what we've done,' David says.

Though the houses were in a bad state, the couple were instantly attracted by the potential of the rocky wet woodland and the sloping paddocks. 'You couldn't really walk around the house because it was so overgrown,' Diane says. 'Initially, we had no grand plan except to start fighting the jungle back.'

Windy Hall occupies about five acres, with a woodland garden climbing about 100 feet between the main house and the top of the hill. Diane and David experimented with planting a wide range of small trees and shrubs for wind shelter there, as well as a selection of Chinese and Japanese plants that would thrive in the Cumbrian landscape. It was also essential to create paths and move stones so the woodland garden could be easily accessed.

From the beginning, Diane and David have allowed nature to give them clues on how to develop the woodland garden. They found that the humid and rainy climate in the area has made Windy Hall an ideal place for moss, ferns and rhododendrons. The most common moss species in the garden, such as *Polytrichum*, have been allowed to appear naturally. Now they play a leading role as ground cover, and create soft shapes that combine beautifully

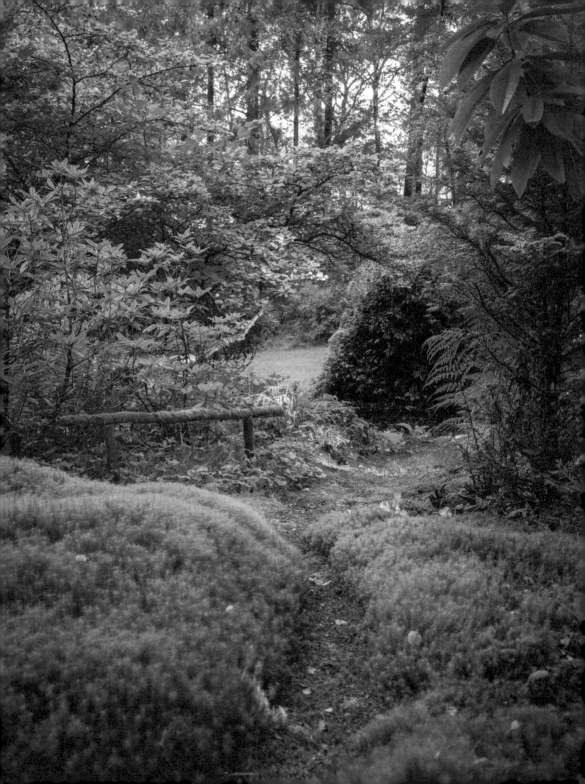

with the male fern (*Dryopteris filix-mas*) and common poly-pody (*Polypodium vulgare*).

Walking through the woodland garden is a breath-taking experience for any moss lover. The edges of the serpentine pathway that follows the natural contours of the landscape are softened by moss, foxgloves, ferns and li-chens. Conifers, willows, alders, birches and shrubs create living walls in different textures and shades of green. At the end of the pathway, you get the sense that you just walked in to a Japanese moss garden. Three Westmorland stone gate stoops are positioned in perfect symmetry and framed by soft pillows of bank haircap (*Polytrichum form-osum*).

Having spent periods in Japan and China in the 1990s, David and Diane were inspired by the gardens they saw there, and came back with ideas about highlighting the moss that grew at Windy Hall. 'Visiting Japan and seeing their moss gardens opened our eyes,' David says. 'We had never seen anything like it.'

Their garden philosophy is simple and especially well-suited for moss: humans do not have to initiate everything and dominate everywhere.

'As retired scientists we are more interested in the wider environment and the interaction of plants and animals,' David says. 'We tweak things, but prefer to step back and let the plants tell their own story.'

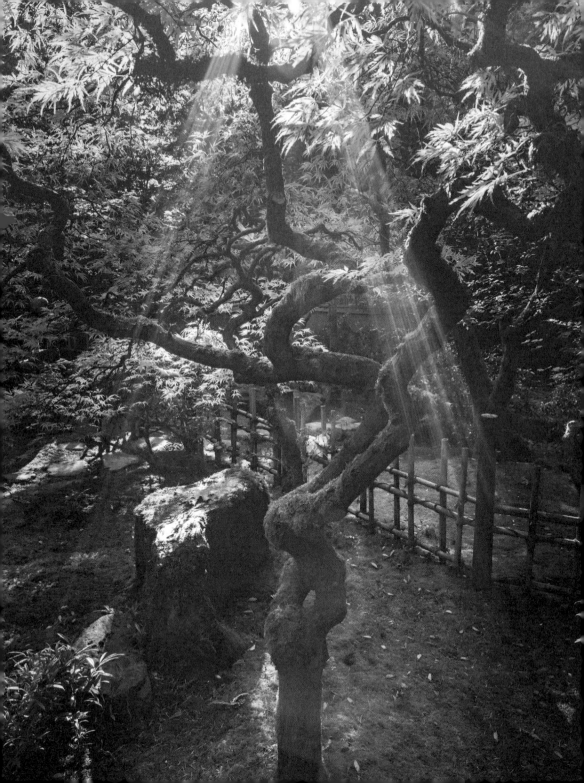

Portland, USA

Portland Japanese Garden

When visiting some of the best moss gardens in Japan, expectations of the equivalent elsewhere are high, to say the least. Are there any gardens in other countries that can match these wonders? Portland Japanese Garden can do just that. When we visit the garden in late October, it is almost unbelievably beautiful with the maple-red cherry blossoms that flare up like flames from the green carpets of moss.

The garden is located in Washington Park on the wooded hills of central Portland in the state of Oregon. Until the 1950s there was a zoo on the site but after the Second World War the then Mayor Terry Schrunk, together with committed citizens, decided to build a Japanese garden as a symbol of cultural understanding and reconciliation. In 1961, Japanese landscaping architect Takuma Tono of the Tokyo University of Agricultural Sciences was hired to draw the garden, and six years later it opened to the public.

The unique thing about the design is that Tono combined several different garden styles to create the garden. There is an entrance garden, a walking garden with pond, a natural garden, a stone and sandy garden, and a classic tea garden.

When the Portland Japanese Garden was built, there were no mosses in the garden, although there was an idea of establishing them in the long term. In the 1960s and 1970s the trees were much smaller, which made the whole place both sunny and warm and not ideal for moss. But when the trees grew and more shade came in, the mosses began to spread, and then they simply took over. Today, there are almost no grass-covered areas left in the garden; instead, the garden is dressed in soft moss mats. Over almost the whole area, except for the waterfall, the mosses have been encouraged to grow with very little effort. The

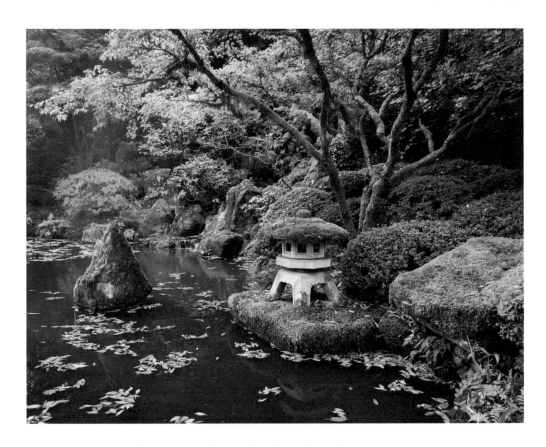

moss grows so well that there is a risk of covering the ornamental stones, which are instead kept clear, allowing their own beauty to show through.

Aside from the fact that Oregon has cool, rainy winters and springtimes, which is ideal, the soil on the site has the correct acidity level for moss. There are many different species of moss there, and plait moss (*Polytrichum commune*) is the most common. But for the eight gardeners working there, it is particularly important to map exactly what species are found on the site. There are no signs that describe the plants or mosses that visitors see in the garden. The focus is on the experience of being there. Witnessing its beauty and taking part in its philosophy are the priority.

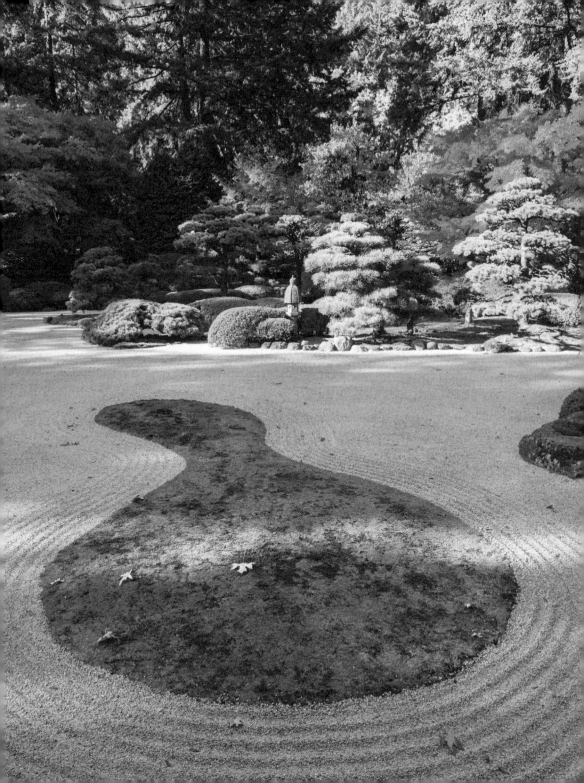

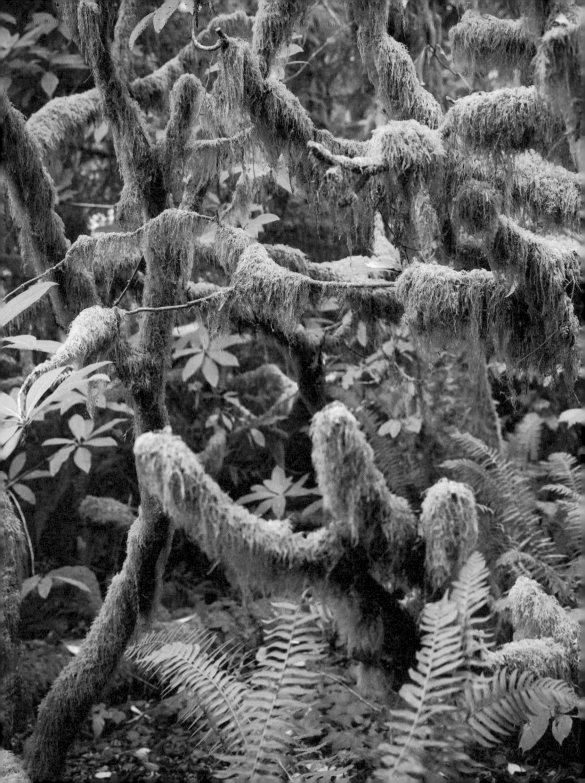

Bloedel Reserve

Bainbridge Island, USA

In the north of Bainbridge Island, a short boat trip from Seattle, is the Bloedel Reserve. It's a sixty-hectare collection of scenic gardens around a summer house belonging to Prentice Bloedel, the founder of a very successful Canadian timber company. In 1951 he took early retirement and settled there with his wife Virginia. Together they decided to create a landscape with gardens, meadows and lakes in beautiful and sustainable ways that would fit into the surrounding forests. During his professional life, Prentice had been a carpenter with a great interest in nature. He was especially fond of stumps and moss in the woods around Vancouver. A visit to the University of British Columbia's Japanese garden in the early 1980s gave him the idea to try a moss garden of his own. He found a suitable place, cleared the ground and planted 275,000 pieces of Irish 'moss' (*Sagina subulata*). This is a moss-like plant that grows across the ground in carpets but, despite its name, is not a member of the moss family. The *Sagina* was eventually overrun by local moss species. Today there are about fifty different species of moss that spread out over stumps, fields and tree trunks. Prentice had a fondness for fine wood specimens and he put in many. The old stumps have now become home to species like four-tooth moss (*Tetraphis pellucida*), creeping fingerwort (*Lepidozia reptans*), and local species that grow in the north-western United States.

The moss garden has, of course, changed over time. At the beginning there were no footpaths. They were created when the reserve was opened to visitors for the purpose of seeing the moss garden as an entrance hall to the area's crown jewel, a low pond with a bottom of black stone reflecting the trees and surrounding nature. A gardener was already employed when the Bloedels moved to the area. However, Prentice was very involved in the development and management of the garden. It was important that the

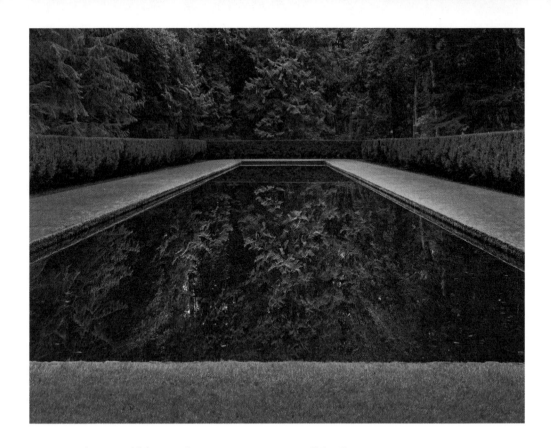

moss garden would be as close to nature as possible. In late autumn, when the leaves fell off the trees, he insisted that they should remain, even though rubbish, leaves and weeds were removed during the rest of the year. He also devoted himself to measuring the groundwater levels once a month with a self-made meter to make sure that the environment was as favourable as possible for all the trees, moss and plants. Prentice died at ninety-one years old, just one year after the Bloedel Reserve was taken over by a foundation and opened to the public in 1998. Since then, the moss garden has continued in his spirit and is a fine example of a place where you can experience the diversity and beauty of moss in interaction with local nature.

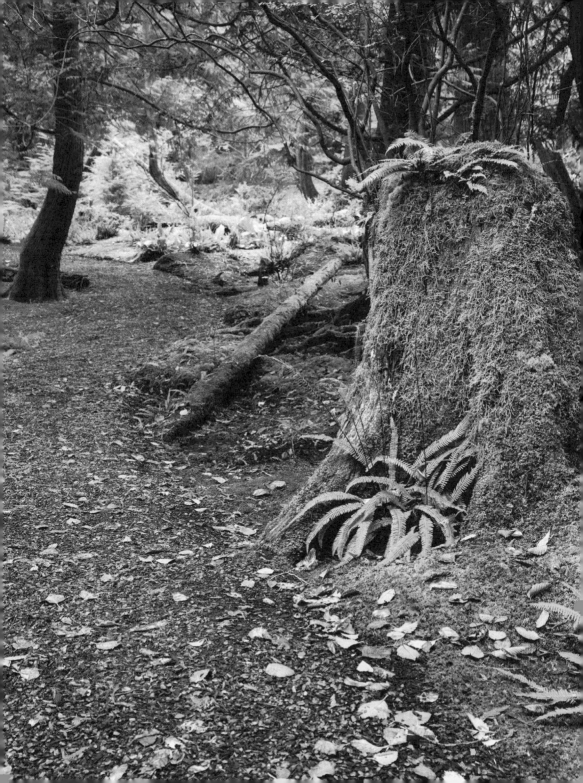

Adam Hart
Gardener
Portland, Oregon, USA

'My goal has always been to work with Japanese gardens. There is something in the aesthetics and how they are built that I always liked. I really love going to work every day.' After nine years as a gardener at Portland Japanese Garden, Adam Hart has learned a lot about mosses and how to appreciate them in all their variety. So much so that he is now working on building a small moss garden at the house where he lives in Portland.

'Mosses are truly unbeatable as ground cover. They're a smart way to get beautiful green land all year round. And I love the naturalness of moss, not having to deal with a lot of fertilisers and having grass that has to be cut.' There are just over 350,000 visitors per year to Adam's workplace. The garden is open all year and is managed by him along with seven other gardeners and volunteers. A large part of their daily work is devoted to maintaining the garden, cutting trees and plants and making sure the mosses are doing well. 'We remove leaves daily, and in autumn we use a leaf blower to keep the moss clean. During spring and summer we sweep away the needles that fall down from the juniper trees and the Douglas firs with bamboo rams.'

Given the large area, it is hard to believe that, since the 1980s, very rarely have they needed to plant moss in the garden. The mosses are everywhere and have spread on their own. 'It has been especially nice to see the haircap moss spread and take over. It's my favourite and I think it's so beautiful with its deep green colour. In places where we have exposed clean land for various reasons, we have instead prepared the surface so that it has become moss-friendly and then waited for the mosses to take hold. The few times we have transplanted moss we have done it from other moss-covered parts of the garden.' The most common question Adam gets from visitors from other parts of the United States is how they grow the moss so well. Many want to know what the secret is.

'I never have a good answer except that this is a very good place for moss to live.'

Bob Braid and Darren Strenge
Gardeners
Seattle, Washington, USA

Bob Braid is like a living reference book. After thirty years as a gardener at Bloedel Reserve, he knows all the curves on the paths, and exactly when each uprooted log happened when the gardens were set. 'Virginia Bloedel used to lead walks through the garden for plant enthusiasts who took the boat here from Seattle. I had only worked here for six weeks before she left the responsibility for the guided walks to me. Then, of course, I had no idea what I was talking about,' he says, laughing. The moss garden was then the starting point for visitors to the Bloedel Reserve. Bob was responsible for the moss garden for several years before taking over the maintenance of the reserve's Japanese garden.

Over the years, he has learned a lot of tricks for sowing moss, although they are rarely needed in the moss garden at Bloedel Reserve. He is a great advocate of the '*mossöl* method', which simply means collecting pieces of moss that are then dried and mixed together with beer. The *Mossölen* is then spread over the areas where the mosses are to be established. Then they are watered. After two to three years you have a dense moss mat on the surface. 'But I've discovered that the seasonal timing of sowing is most important. If you sow too much moss during the summer you will be wasting your time because they are not as active as they are in the winter. At our latitude, it is ideal for such moss to grow between February and March. I could imagine that it is about the same time in northern Europe.'

Bob's younger colleague Darren Strenge has just taken over responsibility for the maintenance and care of the moss garden at Bloedel Reserve. He is delighted with his new area of responsibility and is particularly fascinated by the size of the moss varieties, as they are so small, yet they are able to add so much feeling to a garden.

'As a botanist and gardener, I'm used to focusing on the visible plants. Moss and moss gardens are the underdogs of the world of plants, and I like it. And the greenery they deliver all year round is on a completely separate level.' Darren tells us that many visitors find their experiences in the moss garden quite magical. Especially in the spring, people tend to be enchanted by all shades of green. But even a trained person such as Bob, who has worked among the beauty of Bloedel Reserve for so many years, is still attracted to the moss world. 'Sometimes I just have to go down on my knees and watch them close up. Among the moss are animals and insects that we usually do not see. It is fantastic. I completely marvel at what a beautiful world it can be down there.'

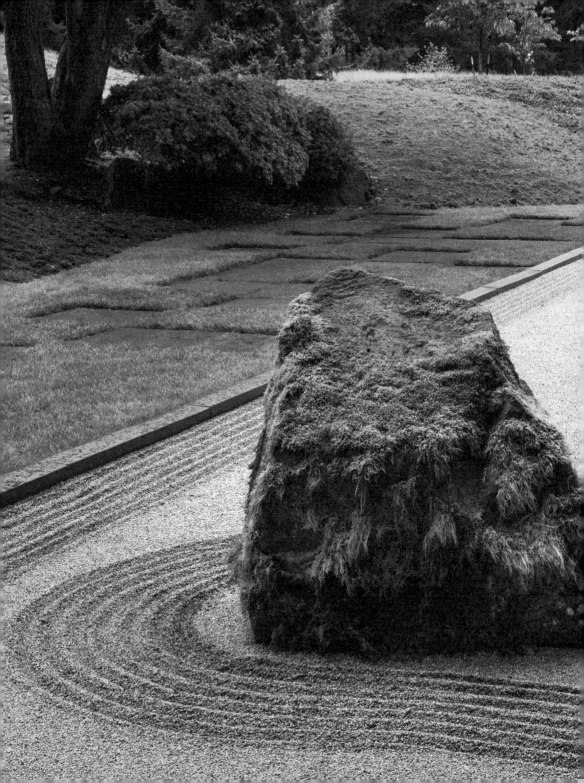

Outdoor moss projects

When visiting a moss garden, one's perception changes about what a garden can be. It is as if the mind is sharpened as you see beyond bushes and large plants, and instead your eyes look downward where you encounter an extensive world of different shades of green. The climate in Britain is beneficial for many species all year round and allows us to experience lush green harmony during the time when everything around is cold and grey. In the garden, moss can also be useful in winter to cover the shoots, bulbs and roots of sensitive bushes. During drier and warmer times of the year, it can help keep moisture in the top soil layer. If you do not have a garden, you can plant moss in troughs, stone pots or other vessels and place them on a balcony or patio.

Choose the right place for the moss

Whether you want to create a large or small moss garden outdoors, it is best to start by charting what conditions actually exist in the place where you want to plant your garden. Mosses have specific requirements for their planting sites. Your aim is to recreate the surfaces and planting environments in which they grow naturally. Three factors are especially important to consider: light, moisture and surfaces. Most mosses enjoy environments that are shady at least part of the time. This is because moisture usually stays there for longer. Planting moss near trees is often beneficial because their cover provides both shade and humidity down near the ground. Mosses that like acidic surfaces with a low pH do well under different types of coniferous trees, such as spruce, pine, hemlock and cedar. These mosses include haircap (*Polytrichum* spp.), large/ smaller white-moss (*Leucobryum* spp.), and fringe-moss (*Racomitrium* spp). These genera can also be advantageously planted around bushes with dense, overhanging growth like rhododendron and azalea. If you want to create a place for moss near deciduous trees, it is good to keep in mind that the light and moisture can change after the summer season when the trees drop their leaves.

If you have a garden which has lots of exposure to the sun and heat, and which has few trees, it may be a good idea to look for a place for the moss near house walls, fences or garden walls that can give a little shade. One tip is to measure the light in the garden to find a suitable place. There are numerous light meter apps that can be downloaded to your smartphone or tablet if you do not want to invest in a light meter.

Other good places to plant moss are on north-facing slopes, near water and on moist soil. Maybe there is a stream nearby, or a low area or depression in the ground where water gathers when it's raining in your garden? Here you can allow smoothcap (*Atrichum* spp.), tamarisk-moss (*Thuidium* spp.), and featherwort (*Plagiochila* spp.), to establish. Water-loving families such as thyme-moss (*Plagiomnium* spp.), and featherwort are good investments around garden ponds or other bodies or accumulations of water. Mosses that grow near water are also more resilient to sun exposure because the nearby water raises the moisture content of the air.

The base or foundation for your moss

Before you bring your plans for a moss garden to fruition, you should identify and get to know the substratum on which your chosen moss prefers to grow. If you are interested in establishing a certain species in your garden, it is an advantage if you can recreate or transplant the soil on which it grows in nature. Stone, concrete, brick walls, peat, crevices between rocks, the coarse bark of trees, clay-type soil or sandy soil, and dead tree stumps are all excellent surfaces for moss. Peat blocks are especially good for establishing certain species because spores can attach to them easily. If you do not already have such surfaces in place, you can bring them in from outside your garden. Using stones that are already covered in moss, plus dead branches or wood from nature, can give the garden exciting shapes and structures. Then note the light and

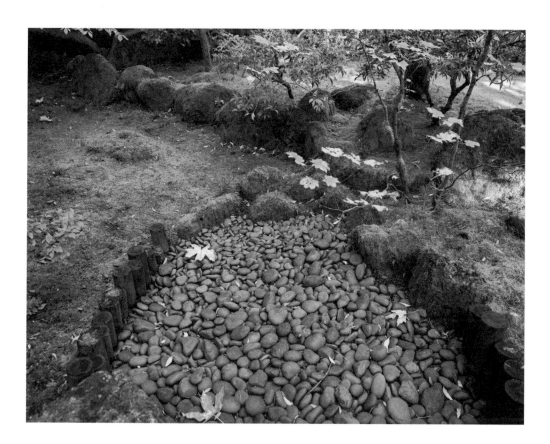

pH is a measure of how acidic or alkaline something is. In pH, 7 is neutral. Anything below that is acidic, and anything above is alkaline. Most of the plants we grow are happy with a pH between 5.5 and 6.5. A pH meter is useful for measuring the pH of soils and substrates and can be purchased from a garden centre.

humidity of the original areas where you found the moss-covered objects and try to find a similar environment for the moss in your own garden.

For the vast majority of mosses, the pH value of the surface is important. Many of our most common species prefer acidic surfaces with pH levels between 5.5 and 6. Outside in nature, low pH levels are often associated with coniferous forests. An easy way to lower the pH of a surface in your garden is to collect soil from a forest and mix it with the soil where the moss will grow. In the Japanese moss garden the Forest of Wisdom (see page 85), muddy sand was taken from a nearby mountain slope and used in cultivation boxes to establish mosses in the garden.

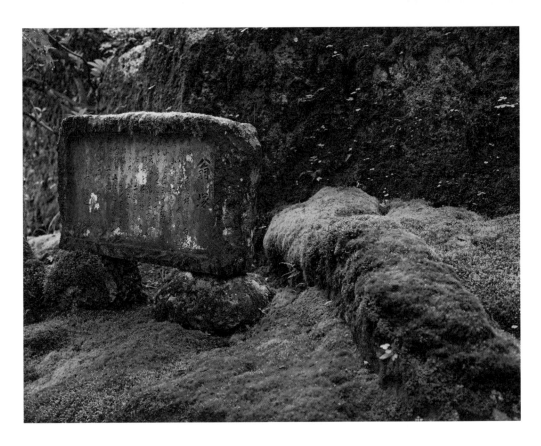

To establish your moss

The windborne spores of moss can arrive in your garden by chance and settle on the soil and other surfaces there. If conditions are right – finding a shady spot with good moisture – they may even establish and grow. However, this may take several years and you may have some areas where you want to speed up the process. It is then necessary to transplant some moss. Transplanting mosses isn't difficult, but requires attention to the specific environment, moisture and light required by different species. If you fail to succeed with one type, be patient and keep trying.

Transplanting

The first thing to consider before collecting pieces of moss from the countryside is, of course, the location they are picked from. Even though the amount you collect will be small, it is important to have the landowner's permission. Try not to take all your moss from one area, and spread your search as wide as possible when picking your moss. Although moss almost always grows back in a few growing seasons, picking, even on a small scale, affects the growth of the plant. Collecting moss on forest land where the trees will be felled or cut is good, as the moss will disappear after felling anyway. Contact forest owners or forest companies and ask about future harvesting sites in your vicinity.

You can transplant moss to many different surfaces: from earth to rocks, roofs, pots or old walls. The best time to transplant a moss mat is between October and March when it is cool and humid outside. It is also best to go out gathering when it is a bit wet outside.

1. Start by cutting out pieces or chunks of moss with a clean knife. Cut enough so that the roots and preferably some soil, if the moss grows on the ground, come with the moss when you lift it. Taking a small part of the surface under the root will make the moss adapt to the new environment more easily. If the moss grows on a rock, try to insert the tip of the knife under the edge of the moss and then remove it from its growing area. Most mosses are easy to move and loosen readily from their substrate because they lack real roots.

2. Prepare and lay out a layer of soil, for example peat- or clay-based soil, where the moss will grow. A layer that is 10–15cm deep is usually enough.

3. Moisten the surface liberally and then water both the top and the underside of the moss pieces to be transplanted.

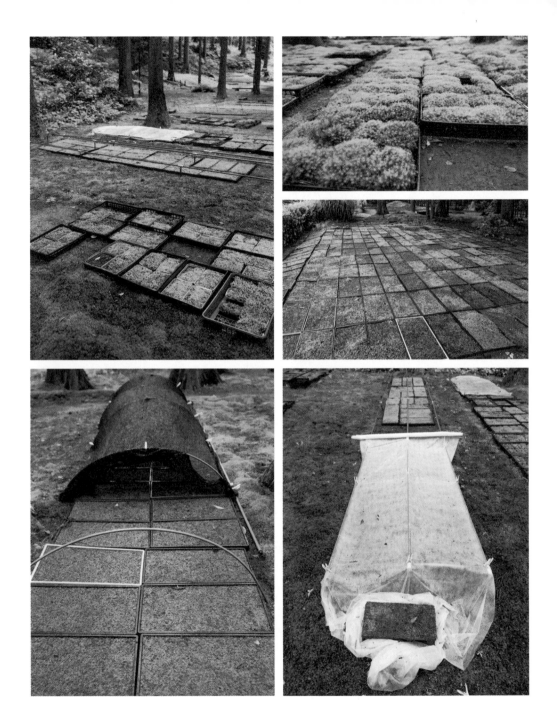

4. Lay the pieces on the surface and push them down firmly. If the surface slopes, you can attach the moss to the base with toothpicks or small sticks.

5. Fill all gaps with leftover soil or peat so that the moss is touching the surface and the other pieces of moss on all sides.

6. Water at least twice a day for the first two to three weeks. Remove any weeds and keep the moss clean from leaves and debris. When you see that the moss is starting to anchor itself to the substrate surface, watering can be reduced to once a day.

7. If you want to coat a stone with moss, press a small amount of clay, peat or soil over the stone's surface. Then push small pieces of your chosen moss on to the stone. Some people have successfully used glue to transplant moss to a rock. Epoxy or wallpaper adhesives are preferred.

Sowing moss from spores

It is also possible to grow moss on its own to use in moss gardens. It may take time for the moss to form dense mats, but it is a method that is kind to nature. It is also beneficial if you only have small pieces of a specific moss species that you want to establish on a larger surface. In order to grow moss you must have spores. The best time to collect them for sowing is in the autumn when many species, such as haircap, have mature spores.

Take some pieces of moss and dry them. Drying the moss is a simple procedure. Put your moss pieces on sheets of newspaper or in open boxes and leave them in a dark place at room temperature for a couple of weeks.

Once the pieces are dry, break them up using a pestle and mortar or a mixer such as an old food processor. The

mixture only needs to be coarse: don't blend for too long or you risk destroying the spores. Then mix the resulting moss 'powder' together with fine sand. Spread the moss and sand mixture on to the soil surface (this is called 'salting'). It is not strictly necessary to mix the moss pieces with sand, but it will make them attach better to the surface.

To sow your moss:

1. Drill some drainage holes in the bottom of a cultivation box or other non-metallic container. Fill the box to approximately 10cm depth with an even layer of moisture-retaining soil, such as sand blended with peat. Water the soil surface thoroughly and flatten it so that it feels compact and stable.

2. Spread your dried moss evenly on the soil. Water well, preferably with a watering can with a fine spray.

3. Put the box outdoors in a slightly shady place and water both the soil surface and the moss so that it is constantly moist.

4. During the first few months, it may be worth covering the box with a mesh a few centimetres above the box, so that no debris falls in.

5. If weeds or other plants begin to grow in the box, remove them.

6. After a few months, the moss should have established itself, but it can also take longer. Have patience!

7. When the moss has grown and is dense enough, you can transplant it to the area you want to cultivate.

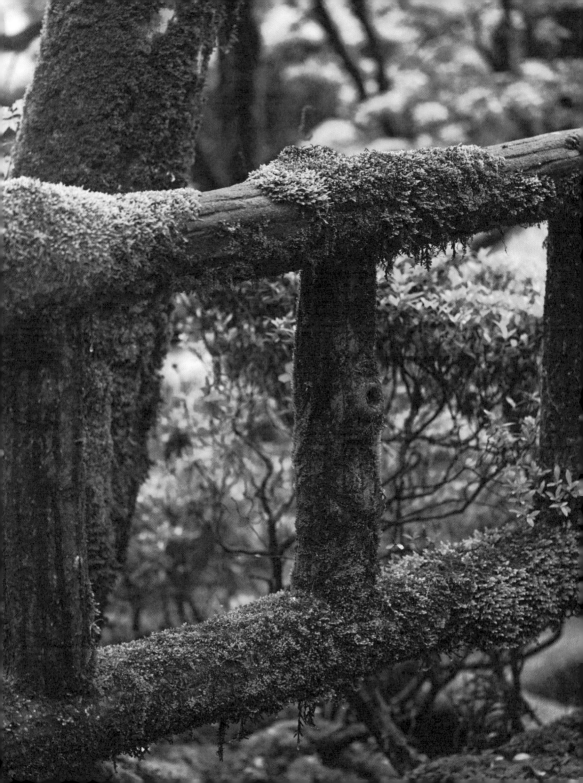

Moss cocktails

For surfaces other than soil, there is a tradition of experimentation with different liquids or 'moss cocktails' smeared on to the surface to see which one helps the moss establish the quickest. You may want a stone, a roof or a wall to have a cover of soft green moss. It is important to prepare the surface to make it as 'moss-friendly' as possible. An old method is to brush the surface with a mixture of one part yoghurt or low-fat milk and seven parts water. Then salt the surface with your dried moss powder. The sour milk creates a favourable pH level for the moss to grow. Herbicides, a means for combating weeds, can also be used to make mosses grow quickly or take over a foundation (just

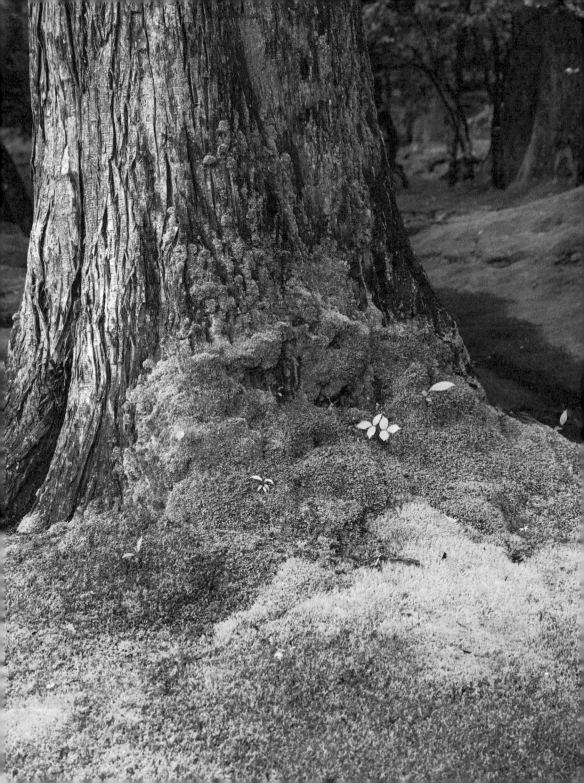

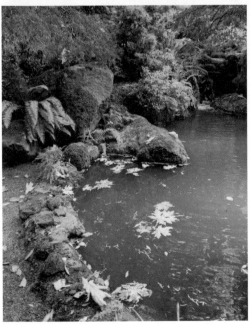

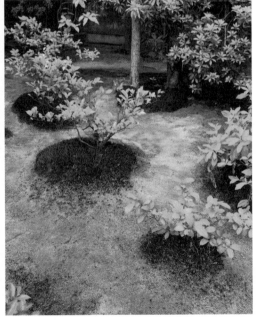

make sure it doesn't contain moss killer). Brushing a surface with the water drained from over-cooked rice is also said to help grow the moss rapidly.

Another method is to use any kind of beer and pour it over moss fragments that you are trying to establish. The beer method works best on flat and slightly absorbent materials such as flat stones or compact ground outdoors. Whichever moss cocktail is used, it is very important to spray the site with water after preparation so that the surface is kept moist. Then water every day for a month or until the moss has begun to grow.

If you have a garden that already contains moss naturally, and, for example, you want the moss to colonise a rocky wall, you can encourage the moss to grow by itself. To accelerate natural growth, simply brush any of the above liquids on to the surface a couple of times and salt with your moss powder. The best time to do this is during autumn or early spring when it is mild and humid outdoors. Trying to grow moss in the summer, when the weather, hot and sunny is often fails. Keep in mind that some species have specific requirements for the environment and the time of year when they grow. Do not despair if one species does not work. Keep trying. Growing moss on specific surfaces is a bit experimental, so have patience.

Places to grow moss

There are many substrates and surfaces that are easy to grow moss on and which can be used as aesthetic elements in lots of different ways. Even if you live in an apartment or do not have a garden, you can still have moss in your surroundings, for example on a balcony or in a backyard.

On the ground or lawn

Are you looking to lay a soft moss mat over a larger surface? If so, it would be ideal to do this where mosses are already

established. This would be a headache for grass lovers but not for those who dream of a soft moss mat. Note the presence of moss and encourage it to spread by pulling up the grass all around. Then prepare this newly grass-free area with a herbicide to combat weeds. So-called weed moss like springy turf-moss (*Rhytidiadelphus squarrosus*), mossa (*Ceratodon purpureus*), and *Polytrichum* spp. are species that easily settle in lawns and in gaps at the edge of lawns and other nooks and crannies. Low pH may cause the moss to quickly take over the grass-free area.

If the moss is not already sprouting, you can improve the soil where you want the moss mat to grow and then transplant it or wait for it to grow naturally. Make sure it is clear of weeds and prepare the soil by mixing it with

peat, leaf compost or pine needles. Keep the surface moist and compact. Over time, the moss, either on its own or with your help, will form a nice carpet on that spot.

On rocks in the garden

If you do not want to cover your whole garden with moss, rocks with moss on them can be decorative elements in a garden or backyard or on a balcony. For example, if there is a pond or natural water source in the garden, you can place some beautiful moss-clad stones nearby. Collect established moss-covered stones from suitable places in the countryside or transplant established moss to attractively shaped rocks. Moss-clad stones can also look good on gravel or adjacent to footpaths. The moss will benefit if the stones are placed in a shady position and are watered regularly during dry periods.

Around plants or fruit trees

Are you thinking of planting fruit trees in your garden or maybe growing an evergreen plant in a pot on your balcony? Plants situated in moist, compact soils with a mixture of peat, sand, gravel, small branches and wood chippings can be extraordinarily decorative with moss growing all around the foot of the plant. Plants such as rhododendron, azalea, lily, kalmia, witch hazel, blueberry and rowan that prefer light shade and moist conditions are an excellent complement to many mosses. Do not forget the old English trick of growing moss around the base of fruit trees! In addition to being decorative, it is also said to be beneficial to the fruit crop by retaining moisture.

A backyard with moss

If you have an asphalt or concrete backyard that needs some life, maybe the cultivation of some moss is something you should try. Backyards can often be both shady

and slightly moist, making them perfect for moss. In addition, if there is a pond it is a perfect time to get started and experiment with growing moss around the edge. You could grow a small amount of moss in a trench of hypertufa (see page 128). Or why not dress a wall with concrete pads that allow moss to grow? Of course, it is also possible to transplant moss to a backyard, but be sure to work with species that grow well in urban environments.

Using peat blocks to create exciting forms

Peat is available in bales in well-stocked garden centres and is an excellent basis for many species of moss. Spores easily adhere to peat and furthermore it is one of the best surfaces on which to transplant moss. With peat blocks it is easy to make exciting shapes like moss-covered hills, stairs or beds. Or you can lay a thin layer of peat on the ground, or on an area of a balcony where you want moss to take over. Do not forget to water the peat blocks both when you lay them out and while the moss is growing.

Roofs

Most small houses, sheds or other small buildings will look extra picturesque with a green roof. Creating a roof of moss on a residential building requires professional expertise. But in smaller, older buildings you can easily create your own moss roof. In Kolarbyn in Västmanland, Sweden, visitors can live in small coal sheds with moss-covered roofs. There they have effectively transplanted moss and plants from the surrounding forest and established them on the roofs of the huts by placing a close-fitting, moisture-proof layer of plastic sheeting on the roof and then moulding layers of peat soil before transplanting the mosses on top. Of course, the surrounding forest helps to create a perfect balance of shade, humidity and rain. There are also lots of mosses that spread across the natural pathways to the huts.

On roofs that are coated with moisture-retaining bricks or roofing mats, mosses have the ability to establish themselves. On this type of roof you can speed up the process by brushing on a moss cocktail before applying the moss powder.

If you want to establish a moss mat on the roof of a small building there are a few things to keep in mind:

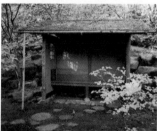

Location: the roof should preferably have a semi-shady to shady position and the building should not stand out in the open so it is exposed to excessive wind. Strong wind in combination with direct sunlight can easily dry out the moss surface. In addition, transplanted moss can blow away if you do not use glue or attach it with sticks.

Strength and dimensions of the roof: keep in mind that the roof will have to cope with the extra weight that the moss layer will develop when it rains. The thicker the peat or soil layer underlying the moss, the stronger the roof that is required. The moss and its growing substrate should therefore be adapted to the condition and construction of the roof.

Angle of inclination: on steeper roof slopes, it is better to work with thinner moss beds, while on shallower roofs you can work with thicker soil coverings and maybe even combinations of mosses and other plants. Heavy coverings may slide off steep roofs.

Local customisation: when it is time to transplant the moss to the roof, it is best to choose species that are available nearby and that are already adapted to the local climate. Do not transplant mosses when they are frozen because it is harder for them to attach to the surface. Early spring or late autumn is the appropriate time to plant the moss.

Hypertufa as a trough, block or wall

Growing plants in old troughs is a tradition that originates from England where, during the nineteenth century, washbasins and bathtubs started to be made from more modern materials, and older stone troughs were replaced. Old troughs are hard to get today. But a practical person can easily make their own trough of hypertufa, on which moss and algae are known to quickly establish. Hypertufa is a combination of concrete, peat and sand or fine gravel, which can produce a nice effect when mosses grow on it. You can also cast tiles from hypertufa or use it to cover facades, walls and other edges in your garden. If you create your own tiles made of hypertufa, make sure that they are thick enough not to crack in cold weather. If you want the moss to grow directly on the object you have made, brush the surface with a moss cocktail and sprinkle moss powder over the surface.

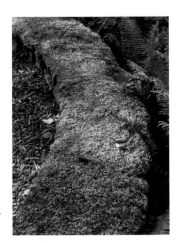

Making a pot or dish of hypertufa

1. Protect your hands by wearing plastic gloves. Mix equal parts of cement, peat and sand. Pour in water and stir until you have a smooth mixture that has the consistency of thick yoghurt.

2. You need two template vessels or moulds. You can use a ceramic, metal or plastic pot, dish or saucer of the kind used for garden planting. One should be bigger than the pot or dish that you wish to make, and the other should be smaller. They should fit inside each other with a comfortable gap of at least a finger's thickness between the two. Dip a paint brush into rapeseed oil and brush oil on to the inside of the larger vessel you are going to pour the mixture into and the outside of the smaller vessel.

Materials and tools:

- 1 part cement, mixed according to instructions on the bag.
- 1 part coarse sand or fine gravel
- 1 part moist peat
- water
- rapeseed oil
- 2 metal or plastic vessels, one bigger and one smaller, to be the moulds
- some corks
- plastic gloves
- stick and shovel to mix with

Casting the trough

The finished result

3. Pour the hypertufa mixture into the large container until it is 2 or 3cm below the height that you want the finished dish to be. Use a metal trowel if necessary. Shake and gently tap the outside of the container to get rid of any air bubbles and to ensure that the top of the mixture is even. You can also flatten the surface evenly with a flat tool, such as a cake slice or pointing trowel. Discard any leftover hypertufa as building waste. Do not wash the remains into a sink or toilet.

4. Make an estimate of where you want to position the smaller template container inside your finished container, and then push one or two short lengths of wooden dowel, about 1cm in diameter, into the mixture until you feel that they hit the bottom. These will form the drainage holes. The dowels need to be about the same length as the thickness of the mixture after you have placed the inner vessel inside the outer container.

5. Put the smaller plastic, metal or ceramic container in place on top of the mixture, and pour gravel into it until it drops to the depth that you want for the finished container.

6. Allow the mixture to dry for about seventy-eight hours. You will know it is dry when the colour has become bright and the surface feels hard and dry.

7. When your new vessel is dry, remove the inner vessel by gently loosening it. Do the same with the outer vessel. Once out, gently push the dowels out of the drainage holes and use a metal file to smooth the edges or irregularities. Remove any debris from the drainage holes with a chisel. Wipe off the vessel, first with a damp cloth and then with a dry one.

8. Plant the moss in your new vessel!

Care of outdoor moss

Unlike other garden plants, outdoor mosses are not particularly difficult to handle, but they do still require good and regular maintenance. To manage your moss plant, you need to do this: *water the moss often*. Regardless of whether you have applied a moss mat, established moss on a roof or created moss-clad stones, your plant requires moisture. The moisture level of the surface on which the moss is growing is not the only thing that plays a role in the well-being of the moss: it also needs humid air around it.

In Scandinavia and in the UK, mosses in the garden, especially during dry periods in the summer, must be watered to keep them in good condition. The ultimate and easiest way, of course, is to install a sprinkler system that can produce lightly dispersed water (like drizzle) in the garden. Most large moss gardens use sprinklers for big areas. If the sprinkler is connected to a water source that uses rainwater it is also good for the environment, but it is not more beneficial for the moss.

If you do not have a sprinkler or just have a small moss plant to take care of, then water it with a refillable pump-spray bottle. They are widely available in garden centres. Of course, it is also possible to use a normal watering can, but make sure that it has a rose with fine holes in it so that the water is lightly dispersed over the moss. Avoid metal water jugs because mosses are sensitive to metal deposits. If possible, use rainwater or tap water that has been left to stand for twenty-four hours before watering.

There is no reason to worry if your moss dries out at any time. Mosses tolerate drying out better than we might think, but they can change colour when dry and become more sensitive to wear when they are not moist.

Removing rubbish and leaves

It is important to keep your moss clean from leaves and rubbish. This maintenance, of course, increases in fre-

quency during late autumn and if you have moss near any large deciduous trees. For larger areas of moss you can use a leaf blower if you have one. Japanese gardeners sweep leaves on to bamboo mats when tending their moss gardens. The leaf litter can then easily be tipped into the compost bin or waste bin.

Be sure to pull up any intruding plants and weeds that spring up in or around your moss patch. Clear other plants from the moss and avoid planting a moss mat near plants that spread easily, such as the evergreen *Vinca minor*, grape lily (*Liriope muscari*), ivy such as *Hedera helix* and azure bluet (*Houstonia caerulea*). Do not see it as a loss to not have these plants around your moss spot. You want to find a home for your moss that is not limited by other vegetation so that the moss is really emphasised!

Mosses generally have few enemies. It is unusual for mosses to be attacked by pests, and they are also able to survive under snow. On the other hand, they don't like lime or fertiliser so these should never be added (lime will raise the pH of the soil above the moss's preferred range).

If you have succeeded in establishing haircap (*Polytrichum* spp.), it can grow high and randomly over time. If this happens, you can cut it back a little bit without damaging it. Some mosses have fast growth, forming very thick rugs, and as a consequence can sometimes have low oxygen levels around the trunks. These mosses can be ripped carefully to increase the oxygen supply down among the trunks.

Making creations using common haircap

Common haircap (*Polytrichum commune*), is a fantastic species of moss to craft with. It is a durable moss that grows in long tufts and is therefore suitable for many different types of craft project. Having a moss mat to decorate with braids or wreaths of haircap outdoors in the summer is an old Nordic tradition from the countryside that has almost fallen into obscurity. It's a pity because it's an easy way to liven up boring surfaces with something that is both

beautiful and practical. Anna Karin Reimerson, whom you met on page 50, has provided tips on how to make a carpet and a brush of haircap.

When picking the haircap it is easiest to pull a fistful at a time. Try to spread where you pick from – by taking tufts from here and there you will not damage the plant surface too much. To make a broom, only a few tufts of moss are needed. To make a round mat with a circumference of 40 to 50cm, about half a bag of moss is needed.

If you have got too much haircap, it can be frozen for later use. In the freezer, this moss does not lose its colour, which is useful if you want to make something in the winter when snow and ice can make it difficult to collect haircap from its forest habitat. A moss mat stays green and vibrant during the summer if you water it frequently. Over time they can lose their colour and become a golden brown. When haircap dries out it also becomes brittle. For moss brushes you do not have to do anything at all when this happens, it's just that the moss will change colour as it dries.

Haircap moss is not very flammable, so it makes an excellent brush for sweeping fireplaces with. When dried, it is a golden-brown colour.

Making a haircap carpet

1. Remove any debris from the haircap so that you have clean tufts.

2. Divide it into three even sections, then cut and lay them on a flat surface, with the green part of the moss upwards. Tie a cotton thread at one end.

3. Braid by folding one of the outer bundles towards the middle as with a regular plait. Make sure that the braid remains tight. Then put the next moss bundle on top of what you just braided. Continue braiding in

Materials and tools:

Plenty of haircap moss, not less than 25cm long. It can most easily be found in open, wet ditches, and surrounding marshes and swamps

- 4 strong, narrow sticks with tips sharp enough to push through the braided moss
- Twine, for tying up the ends

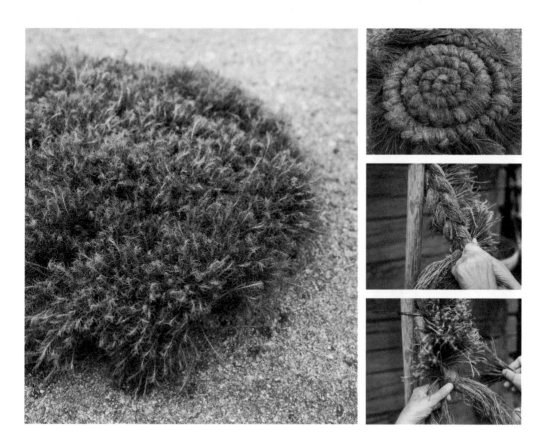

the same way keeping the green moss on top and the brown stems underneath.

4. When you have a 2- or 3-metre-long braid, tie the end together with string.

5. Now roll the moss into a spiral to form a round or oval mat. With the underside of the braid facing towards you, make sure that the end you started with is the centre of the carpet. Roll it tightly and make sure all the green moss spreads in the same direction. As the spiral grows, push a stick through to anchor the inner loops of the braid together.

6. Then take the other sticks and insert them so that they cross the first one. They should resemble the spokes of a wheel. Each pin should be crossed by a second one to ensure a firm hold.

7. Turn over the carpet and brush it with your hands so that the green moss is like a rug. Your carpet is ready!

Making a haircap brush

Brushes of haircap are excellent for sweeping ashes and debris from tiled ovens, fireplaces and stoves because the moss does not burn easily. If you tie the shaft with ribbons, roots or any other strong natural materials, the brush will be really decorative.

Materials and tools:

- Bear moss
- Ribbon, twine or roots
- A sharp knife

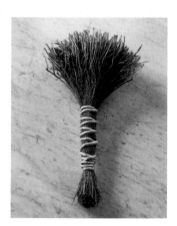

1. Take a largish fistful of fresh moss and clean away any debris.

2. Lay out all the strands so that they are level and smooth.

3. Begin to wrap and tighten the roots or strings at about 4cm from the end of the brown trunks. Tighten and wind down to the green part of the moss to form the handle of the brush. Keep in mind that moss shrinks when it dries so tie it as tight as you can.

4. Cut the end of the shaft with a sharp knife so that it is neat and even.

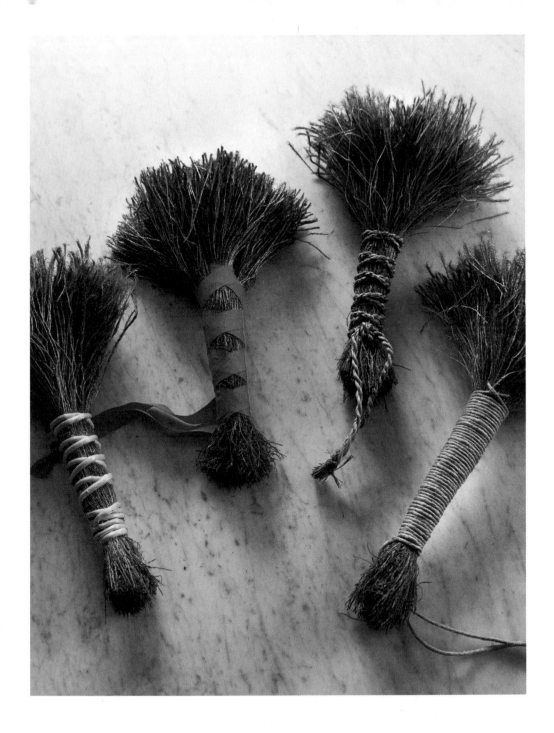

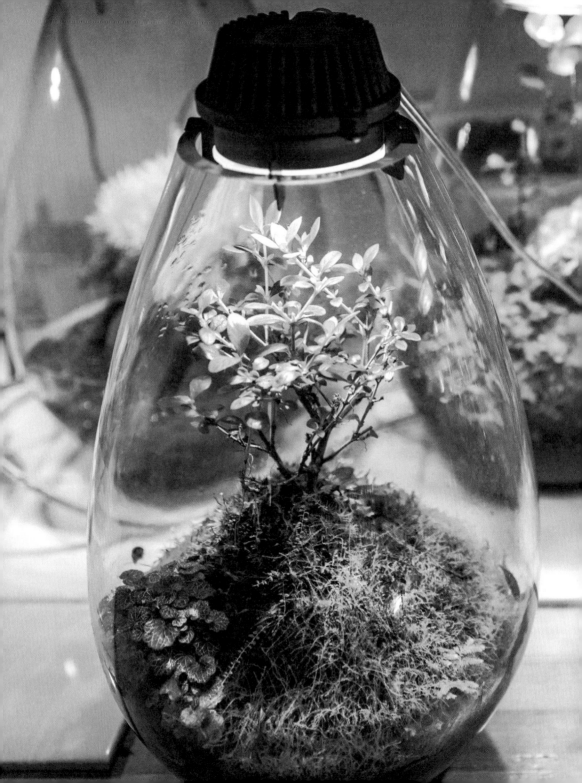

Indoor moss projects

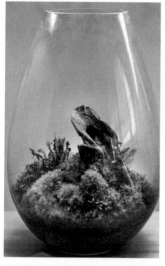

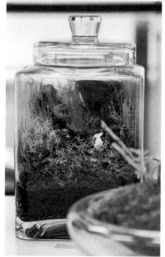

In my native Scandinavia and in the UK, we are so used to the fact that mosses are just something we encounter outdoors that it is easy to think they are plants that cannot survive indoors. This is a misconception. Just look at the mosses grown together with bonsai trees that often live indoors. Mosses can both grow and thrive in our homes if we create the right environment and provide them with good care. For city housing, moss in the home can create a sense of closeness to nature and to a green landscape. In the end, by trying to create small moss landscapes maybe we are mimicking and recreating the great outdoor landscape to care for and admire in our homes.

On the following pages, a number of plants in different types of indoor containers are described step-by-step. The containers vary in shape and style, but they contain different types of moss and can be created in one or two hours. My wish is that these projects may be the basis to inspire your own ideas about plants, materials and containers for you to create your own moss landscape indoors. It is a creative challenge that goes a little further than the nursing and retention of a pot plant, and with the proper care it will result in a new, exciting plant in your home for some time to come.

Pots, vessels and natural substrates
for your moss

Making small moss landscapes in different containers can provide the opportunity to combine, test and use moss species that are sensitive to some outdoor environments. Even in small containers, different mosses can live together with other small plants as long as you are aware of their individual characteristics and needs. What you choose to plant in your landscape really is a matter of your own opinions and taste, except that the container needs to be of a depth that is beneficial to the well-being of the plants.

If you want to keep a pot with just moss in it, a pot that is at least 5cm deep is recommended. If you combine

moss with miniature plants or small perennials, the depth should be at least 15cm and the container should have at least two drainage holes.

Planting moss in a translucent glass container with small openings or caps is a very good way to allow moss to thrive indoors due to the humidity created and retained by the glass. Moss can live, and even grow, for several years in glass vessels. In lidded glass, it is possible to establish more compact moss species that grow in a natural environment around water and that would not be able to live in an open container. Of course, you do not need to limit yourself to traditional vessels when creating your indoor moss landscape. Mosses are found outdoors on everything from rocks and stumps to branches, tree trunks and abandoned rubber tyres. All of these can also, if you find them aesthetically pleasing, be used as a foundation for your moss or as separate elements in your own miniature landscape.

Surface and soil

The surface you use for your landscape depends on whether you combine moss with other plants in your landscape. If you are just working with moss, it's great to fill the bottom of an open container with sand or gravel that you then cover with a layer of wet peat or soil that has a low pH and is nutritionally poor and moisture-retaining. Most garden centres sell peat-based soil that contains peat and bark which is ideal for growing moss. If you are planting moss that you have transferred from outdoors, it is good if you can also include some of the soil on which the moss grew. If you want to include indoor plants in your planting, it is best to know their needs because they will draw nourishment and moisture through their roots. Then it is also important to have a layer of drainage material in the planting, such as a single layer of moisture-retaining granules at the bottom of the vessel. If you want to plant moss around the plant you can add a thin layer of peat or soil

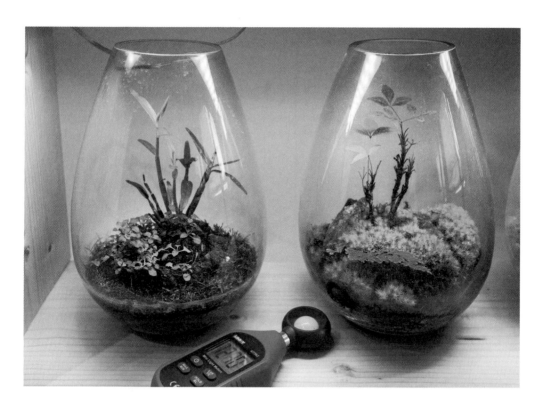

to establish the moss. Keep in mind that both the surface and the moss should be moist when planting to ensure good contact.

Light

Before starting to choose mosses and plants for your landscape, you should consider where the finished planting will stand. Mosses thrive in some shady environments outdoors, but indoors the light is different. Do not set a plant in a south-facing window with the direct sun on it. Instead, find a place for your landscape where it is exposed to daylight but not excessively so. Make sure that the plants you put with the moss have about the same light requirements as the mosses that you use. Indoor environments are dry and houseplants are small: they

quickly dry out. Therefore, it may be a good idea to focus on moss species that grow in slightly lighter and more open surroundings in the wild. Certain mosses, such as the urn haircap (*Pogonatum urnigerum*), are a species often found in sun-exposed and drier places in Japanese moss gardens. If you have built a moss landscape in a glass with a small opening, it needs to stand in a light area but not in a place that gets too hot.

The design of your moss landscape

How to design your moss landscape is mostly a matter of style and taste. Personally, I allow nature to inspire and please me so I include stones, sand, branches, driftwood, bark, shells and other natural elements as top layers in the landscape. Go out into the countryside and look for inspiration around you, or visit a well-stocked aquarium store, which often has a good range of wooden artefacts and sand. Minerals and stones from all corners of the world are now commonly available in specialist stores.

Sand and gravel in various dark and bright tones can be used to give the illusion of streams or paths. For example, with some larger natural stones or driftwood you can create mountain peaks or rocks. In Japan, it is popular to make a moss story with different miniature figures that are playful, like fairy tales.

Care

Mosses are not so picky in terms of surface but for indoor planting, especially in the winter, when heating makes our homes very dry, it is very important to water mosses that are planted in an open container. It is necessary to spray moss in a pot at least once a day, preferably twice. If you have planted the moss with other plants, it is also important to ensure that the soil gets the moisture that it needs. One way to reach the soil under the moss is to pump water in using a small plastic pipette of the type that

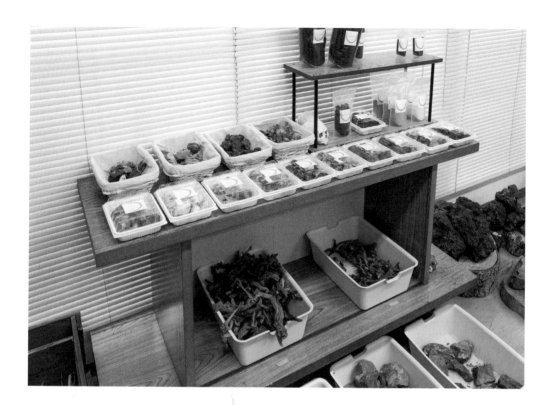

is often available in art shops or well-stocked garden centres. The smaller the vessel, the faster the soil and plants will dry out. Therefore, keep an eye on your open plants and keep the moss clean from debris and weeds.

Moss terraria made of glass are usually very easy to care for due to the circulation of moisture and oxygen inside the glass. If the light is right, they do not need to be sprayed with water more than once a week. Check regularly how dry the mosses are, and ensure that there is some condensation inside the glass. Conditions for light, moisture and temperature that are good from the start will save a lot of worry and maintenance time in the future.

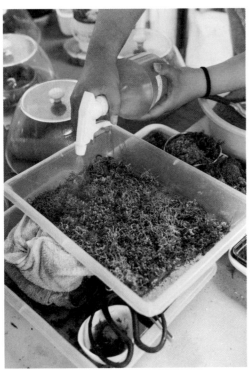

Drought and mould

The biggest threat to a moss landscape in an open container is dehydration. In closed glass vessels, it is the opposite. If there is too much moisture, mould can grow. It is therefore important to check the moisture levels in both types of container. In a glass vessel you should establish moisture with great caution after planting and then water carefully and rarely.

With regard to the size of the glass vessel there are no absolute rules, but the larger the vessel, the greater the space for oxygen circulation and the smaller the risk of mould. If mould does form, try to air the container to reduce the humidity. Then tape a piece of paper towel to a stick and wipe away the mould and excess moisture. Water less often thereafter.

Appropriate soil mixtures for the miniature landscapes

Soil mixtures

Sometimes one wishes to use plain potting compost for planting miniature landscapes, but this is difficult. The soil must be well drained, porous to allow air to circulate and also be capable of retaining some moisture when planting in small vessels that dry out easily. You will need to test various combinations to find a soil mixture that works for the specific plants you are working with. In bonsai cultivation, there are many options for soil mixtures and surfaces that are especially adapted to trees and plants planted in small pots. However, it is important to keep in mind that bonsai trees are usually planted with a soil mixture consisting of larger amounts of clay than a common potted plant can handle. If the amount of clay is too great, the soil will become hard and compact, preventing oxygen access to the roots of the plants.

Potting compost

Common potting soil for potted plants should be mixed with small water-retaining granules. Soil that contains peat and bark for rhododendrons, azaleas and hydrangeas is available in well-stocked garden centres. This type of soil is suitable for plantings that consist only of moss because it has a stable structure and low pH value. Rhododendrons, azaleas and hydrangeas are known as 'lime-hating' in that they prefer low-pH soils, similar to mosses. This kind of compost is often marketed as 'ericaceous' compost.

Akadama, a type of smooth Japanese clay, can be ordered online from stores selling bonsai accessories.

Keto

Soil mixture suggestions:

- 1 part compost, 1 part gravel
- 1 part compost, 1 part cat litter
- 1 part keto, 1 part kiryu, 1 part compost
- 1 part keto, 1 part akadama, 1 part cat litter
- 1 part akadama, 1 part kiryu

For example, combine:

- 2 parts compost with 1 part akadama and 1 part keto to create a mixture ideal for perennial plants and moss

Keto is a mixture of clay soils and peat that is good to use to create shapes in your indoor landscape. Keto is also suitable to use for the outer layer in the creation of moss balls, because it is easy to knead and shape when it is damp.

Kiryu or volcanic sand

Kiryu is volcanic ashes or sand that has favourable drainage properties. There are a number of variants to buy on the bonsai market.

Cat litter

It is possible to replace akadama or keto with cat litter. Basic cat litter without additives for odour control is simply burned clay. The more cat litter and moisture you add, the more mouldable a soil mixture becomes. Look at the list of ingredients on the cat litter packet to see whether it contains close to 100 per cent clay and choose a variant with as little sand in it as possible.

Gravel

Gravel can be used in soil mixes and as a decoration in your indoor landscape. By mixing gravel with soil, you increase the porosity of the soil mixture. Fine gravel can be purchased from garden centres or aquarium shops, and can be found outdoors. If you collect gravel from outdoors in the winter, it is a good idea to at least rinse or even boil it before use, to remove salts that are not good for your plants and mosses.

Bark mulch

• 1 part cat litter and 1 part compost makes an excellent mix to use for kokedama

Dense clay soils hold too much moisture and restrict oxygen that is required by plant roots. Adding bark mulch can loosen it up and improve aeration. Gravelly or sandy soil, which can otherwise lose moisture too quickly, can hold on to moisture better with a little bark mulch added. Bark mulch has a neutral pH. If you buy bark mulch at a merchants such as a garden centre, make sure it is unfertilised.

Peat moss

Different variants of peat moss can be used as a surface layer due to its neutral pH and good capacity for water absorption. Peat moss favours the root development of plants and neutralises the pH in a soil mixture.

Chipped bark

When adding chipped bark, you should preferably use very small chips, around 2mm in size. You can buy very good orchid bark that can be ground into smaller chips.

Perlite

Perlite is a volcanic mineral that can be mixed with plain potting compost. It improves oxygen availability, soil structure and water drainage in the substrate. Perlite can be mixed with other substances or used alone as a surface substrate to obtain a well-draining but also water-retaining soil mixture. However, avoid using with only gravel or potting compost. With gravel it will dry out very quickly and with potting compost it will remain wet for too long.

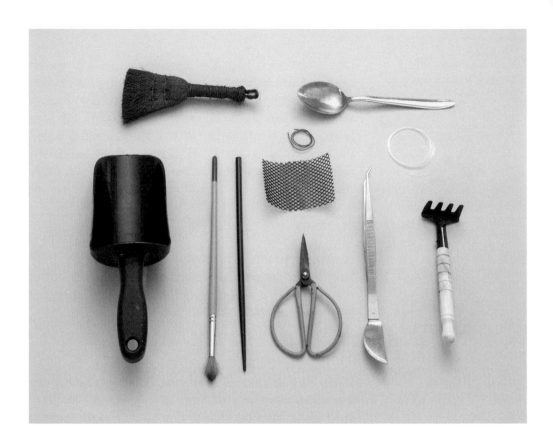

Useful tools

Be creative with the tools you use to build your mini-ature landscape. You can improvise and make many tools yourself, using anything from paint brushes to toilet rolls. For those who do not want to make their own, there are some basic tools that are good to have.

Small broom: use to sweep away soil and debris from work surfaces and tables. The variant in the photo has a soft but bulky brush that does not scratch sensitive surfaces.

Spoon: an ordinary household spoon is good for laying thin layers of substrate, sand or gravel on surfaces that are difficult to access in smaller vessels. Wash with detergent and warm water before use.

Small scoop: to add drainage material and soil to the planting vessel.

Paintbrush: an excellent tool for brushing dust and soil from the leaves of plants or from stones.

Thin stick: I use a wooden barbecue skewer to dislodge excess soil from the roots of plants before planting.

Thick plastic sheeting: can be cut to a size that covers any drainage holes to ensure that soil is not lost during watering.

Wire: holds plastic sheeting in place and can also be used to tie or gather small tree or plant stems.

Scissors: good for cutting and tending the plants and moss. Stainless-steel scissors stay sharp and are easy to clean.

Tweezers: a long pair of tweezers facilitates the work of removing old leaves and other debris from the miniature landscape.

Spatula: a spatula is good for packing and tamping soil into place.

Transparent fishing line: to tie the moss around the kokedama or earth balls.

Small fork: to level sand or gravel.

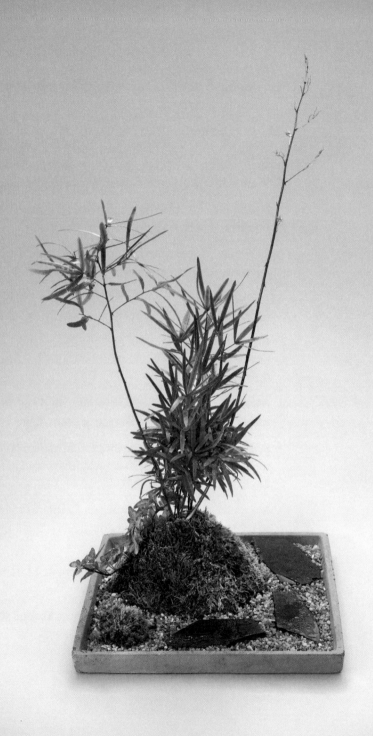

Saikei: a miniature landscape on a tray

Materials and tools:

- ivy plant
- square concrete tray
- fine gravel
- compost
- cat litter
- flat stones
- moss
- spray bottle
- spoon
- brush

This technique is inspired by the Japanese tradition *Saikei*. In Japan, the construction of various miniature landscapes for indoor environments is its own art form. *Saikei*, which simply translates to 'planted landscapes', is a development of bonsai and is simply about creating small, simple landscapes with living plants, soil, rocks, water and other natural elements on trays or pots.

The aesthetic goal of a *Saikei* is that the viewer should see a real landscape in front of them. The tradition was introduced in Japan by Toshio Kawamoto after the end of the Second World War. Kawamoto offered a cheaper and easier alternative to bonsai that all plant-lovers could appreciate and achieve.

In this *Saikei*-inspired landscape there is the climbing *Asparagus falcatus* and the ivy *Hedera helix* planted in a hill of moss on a tray of gravel and some islands of flat stones.

Choose potted plants that are best enjoyed next to the waterways in your miniature landscapes, such as pigmyweeds, *Dracaena* or the like. Suitable mosses include, for example, Cypress-leaved plait-moss (*Hypnum cupressiforme*), or the red-stemmed feather-moss (*Pleurozium schreberi*).

Watering

A *Saikei*-inspired landscape usually consists of small amounts of soil and moss, and therefore dries out quickly. Watering frequently, preferably daily, is therefore absolutely necessary. Water any plant in the soil litter with a pipette directed down to the roots. Mosses can be sprayed both from below and from the top. If possible, place the landscape in a room with higher than usual humidity, which in Scandinavian and British homes is usually the kitchen or a bathroom.

Light

Indirect sunlight is best for this type of planting. Place in a position facing east or west during autumn, winter and spring. During the summer, you can move the landscape further into the room, to avoid strong sun and dehydration.

Set-up and maintenance

1. Take the plants you want to use from their pots and carefully scrape off the soil from the root ball with your fingers. If the roots are thin, scratch off the outer layer of soil and then rinse them under running water until most of the soil is removed. Place the plants on a towel or newspaper and allow excess water to drain.

2. Pour a thick layer of fine gravel on to the tray approximately 1 to 1.5cm deep. Brush it out so that the gravel is evenly distributed over the surface.

3. Find a place for the plants and leave room for stones and other elements. Put all the material in and move it around before you start planting to find a shape of the landscape that you like. Keep in mind that the miniature garden will be seen from different directions so play around before you plant it.

4. Take some slightly damp soil mix, such as 1 part potting compost and 1 part keto or cat litter, and press the soil in place around and under the roots of the plant until a mound or hill forms. Add more water or cat litter/keto if the soil is difficult to shape. The soil mix should be firm but not too wet or too hard. When all the soil is in place, the pile should be able to stand on the tray without falling apart.

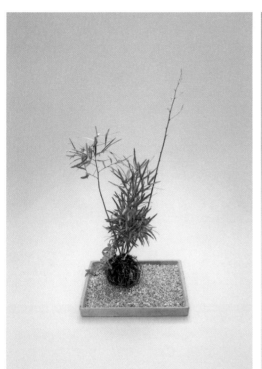 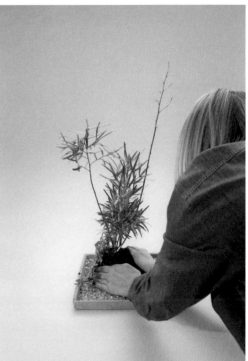

5. Cut the moss into large pieces. Pinch off any reddish brown tufts of moss and soil on the underside. Remove any coniferous waste and debris. The moss to be transplanted should be clean, hold together and have a relatively smooth underside.

6. Spray the outside of the soil with water. Use a watering can or spray that produces a nice soft mist.

7. Spray every single piece of moss with water and then push each into place so that they lie edge to edge and eventually cover the entire soil litter. Visualise it as adding a jigsaw piece to a puzzle. Cut off any excess pieces of moss and smooth the edges against the gravel. If the moss pieces do not fit properly, you can tie some fishing line around the

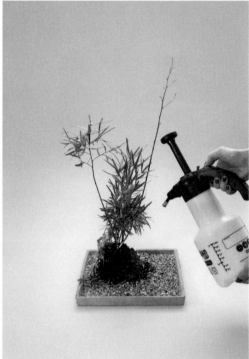

mound. The line can be removed after a few weeks when the moss is established on the surface.

8. Arrange stones and any other material around the finished plant and brush the gravel to level the surface. Spray the mosses and the plants with water.

To maintain your *Saikei* landscape, gently remove plant leaves that have dried or yellowed. If you want to cut a plant or remove any new shoots, do it in the spring. Be careful if you give the plant nourishment that it is not absorbed by the moss, which is best suited to nutritionally poor soil.

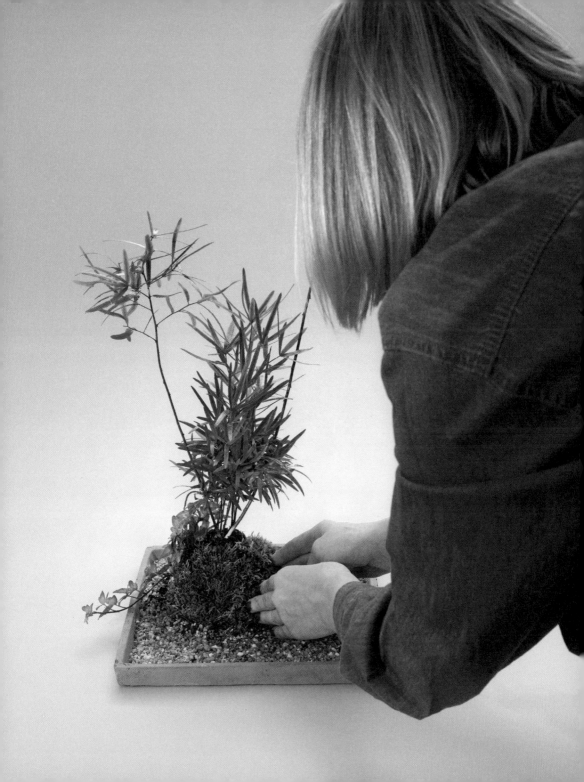

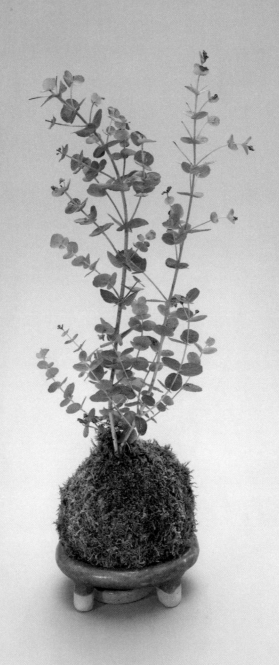

Kokedama: a moss ball with a plant crown

Materials and tools:

- eucalyptus plant in a pot
- keto, akadama or cat litter
- compost
- moss
- fishing line
- spray bottle
- small ceramic dish

Kokedama, which means 'moss ball' in Japanese, is a method of surrounding the root system of a plant with a ball of soil and moss, binding it, then hanging it up on display, with the plant's shoots protruding from the top. It is another Japanese planting technique that has become extremely popular in the West. Making a kokedama is relatively simple and cheap, and the finished plant balls can be displayed in several ways. In Japan, the balls are often hung outside shops and in the entrances to houses.

To form the globe, use a mix of moist akadama and keto. A worthy alternative mixture is plain potting compost with cat litter. Add water to get a firm consistency that is easy to knead. The clay in the cat litter becomes like an adhesive that binds the soil together. In this kokedama, *Eucalyptus gunnii*, 'Azura' and red-stemmed feather-moss (*Pleurozium schreberi*), were used. The kokedama shown is standing on a dish made by ceramicist and designer Lilit Asiryan.

Watering

A kokedama should be watered about every other day. An easy way is to water it in the sink under a running tap. Keep in mind, however, that moss is sensitive to lime water. If you are using normal tap water, try to aim the flow towards the mouth of the plant so that most of the water flows into the soil. Then spray the moss daily with water that has been standing in a watering can for twenty-four hours.

Light

Hang or place your kokedama in indirect sunlight. If you want to hang your kokedama outdoors, try to find a place that is not exposed to direct sunlight.

1. Shake and rinse off any excess soil from the plant's root ball, but keep the soil that is most compacted around and which sits closest to the roots.

2. Mould the root ball into a spherical shape if possible. Trim and cut off very long roots but do it carefully. Just cut off the thickest roots and leave the thinner roots closest to the plant. Spray the roots with water so that they are slightly moist before planting.

3. Take a moistened soil mix, such as 1 part potting compost and 1 part cat litter, and pat the soil in place around the root ball until the roots are properly covered and the structure has a spherical shape. Keep in mind that the soil ball must not be too small, as the roots should have plenty of space to grow. Once you are happy with the shape, spray the whole ball with water.

4. Clean the moss you want to use and cut it into large pieces. Put a damp moss mat in place around the ball and tie it with fishing line. Then fill the moss mat with moss pieces while pulling the fishing line around and across the ball until it is completely covered with moss. Check that the fishing line is taut, secure it with a proper knot and cut off any loose ends.

5. Sprinkle your kokedama with water and place it on a dish. If you want to hang up your kokedama, use the fishing line to make a hanging loop. Keep in mind that the kokedama gets heavier when wet, so make sure you use line that can handle the weight when the ball has been watered.

Tend and remove any dry leaves and cut off any unwanted shoots that grow. Over time, the moss may turn brown, and if you do not like it, just remove the old moss and replace it with new pieces.

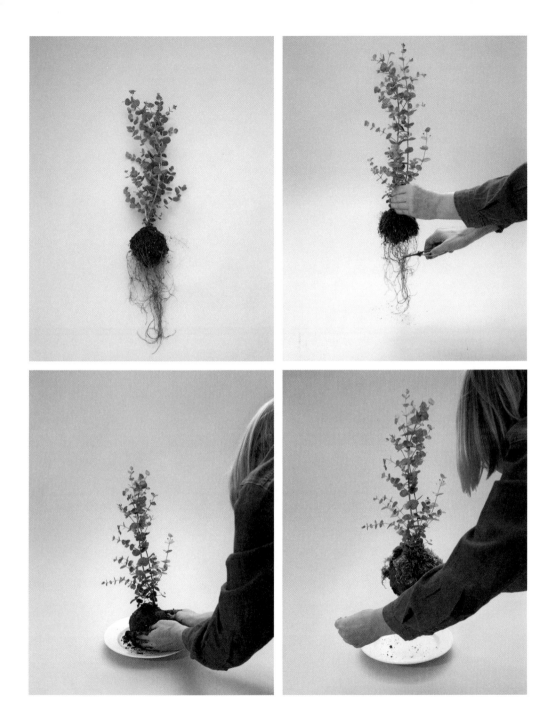

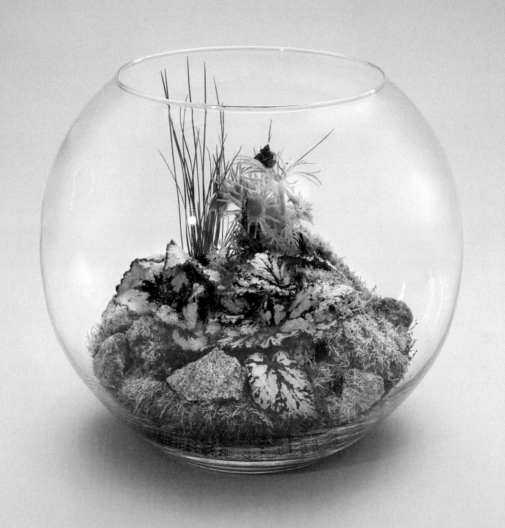

A moss landscape under glass:
open and closed terraria

Materials and tools:

- glass bowl
- water-retaining granules
- perlite
- compost
- plants such as *Pulsatilla vulgaris*, *Rex begonia*, *Carex brunnea* and Cyprus-leaved plait-moss
- stones
- gravel
- spoon
- stick
- spray bottle

A botanical terrarium is a glass vessel containing one or more plants. The history of plant terraria began in Victorian England. Then, the physician Nathaniel Bagshaw Ward (1791–1868) discovered that transporting medicinal and exotic plants by ship became easier when the plants were kept in glass containers that protected them from wind and changing temperatures. With the use of Ward's vessels, plants could be successfully transported between remote countries.

There are two different types of plant terrarium: open and closed. The plants in a closed terrarium cycle their moisture and nutrition, and the humidity of the air under the glass is high. An open terrarium can be used for plants that require an even temperature but which can cope with a drier atmosphere. Mosses benefit greatly from being grown in either kind of terrarium because of the humidity created under the glass.

Creating an open terrarium

In these open plant terraria I have used the flowering plants *Pulsatilla vulgaris* and *Rex begonia*, the grass *Carex brunnea* and the Cypress-leaved plait-moss (*Hypnum cupressiforme*).

Watering

An open terrarium should be watered twice a week and the moss may need to be sprayed daily. Use a pipette to water the soil under the moss. You will know whether the soil is moist by weighing the terrarium in your hands before and after watering. The terrarium will feel significantly heavier when the soil is moist.

Light

Place the terrarium in a spot that gets only indirect sunlight. Keep in mind that glass can get very hot if it is near a sunny window, so move the terrarium further into the room during the summer. If the light comes from only one direction, rotate the glass periodically to allow light to reach all plants inside.

Set-up and maintenance

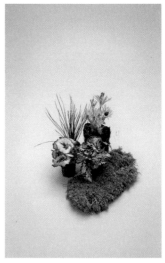

1. If the plants are relatively small you do not need to remove more than possibly the top layer of loose soil when lifting them out of their pots. Clean the tops of the moss pieces you want to use in the terrarium and remove any old moss from the underside. Keep a little of the soil layer if you picked the moss outdoors.

2. Pour water-retaining granules to a depth of a few centimetres into the bottom of the container. Make sure the layer covers the entire area you plan to plant.

3. Mix a little perlite into some potting compost and pour about 10cm of the mixture over the water-retaining granules and flatten to level the surface.

4. Position the plants and rearrange them until you find a composition you like. Turn the glass to check that their positions look good when viewed from all directions. Push down the clusters of plants into the new soil layer.

5. When all the plants are in place, fill up with more of the soil mixture and mould the soil to get the shape you want. Water with a spray bottle.

6. Add stones and any gravel you want in the terrarium. Push the stones slightly into the soil so that they are held in place.

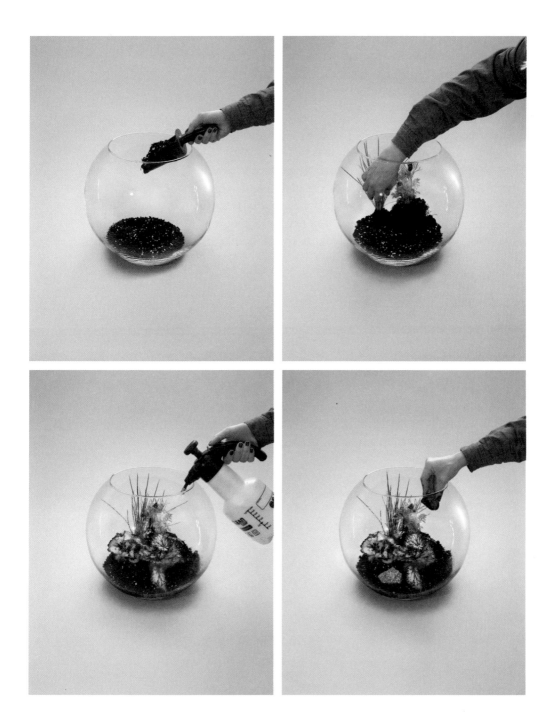

7. Place your moss pieces on the soil. Use a stick to poke the edges of the moss under the stones. Press the moss down so that it has good contact with the surface.

8. Check to make sure the landscape looks good from all directions and spray the moss again with water.

Tend and trim any plants that begin to grow out of the vessel. After a while, the inside of the glass can become dirty and may need to be cleaned. If you have difficulty accessing the inside of the glass, you can tape a loop of paper towel on to a stick, to help you reach difficult areas.

Creating a closed terrarium

Materials and tools:
- lidded glass vessel
- moss, such as broom fork-moss
- a small plant such as a Boston fern
- sand
- compost
- spoon
- stick
- spray bottle

It is fascinating how the plants in a closed terrarium create their own small ecosystem. In closed terraria, dead leaves are not removed, but are broken down naturally to return nutrients to the soil. This mimics the natural ecosystem in nature. You can let the system run by itself with little maintenance.

Watering

Closed plant terraria should be watered only very rarely after the first watering. If the terrarium is in a position where it is exposed to indirect daylight the system will run naturally by itself, cycling water moisture and oxygen. Check the moisture level inside the glass after about two weeks. It is good to see some condensation on the inside of the glass, but when the drops are running downwards, it is time to air out the terrarium. You can vent it by removing the lid for a day. Should mould form on any of the plants, wipe it away with a paper towel and air the terrarium for a couple of days.

Light

Place your plant terrarium in a spot with light, but avoid windows with direct sunlight and other sources of heat. Remember to rotate the terrarium occasionally so that all sides get light. You can set your terrarium in a spot without daylight and instead buy a 2–4 watt LED lamp for it. Keep the light on during the daytime and turn it off at night.

Set-up and maintenance

Set-up is the same as for an open terrarium.

In terms of maintenance, in smaller closed terraria the plants may need to be cut when they become too large for the vessel. Both moss and other plants can be cut or

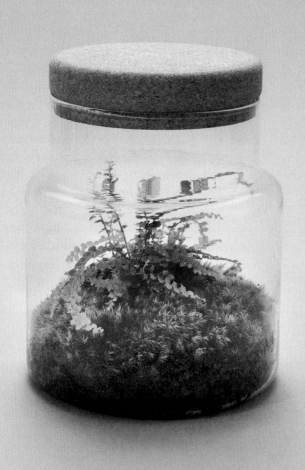

trimmed back carefully if you do not want to complete-
ly replace them. The most common problem with closed
plant terraria is that too much water is applied during
planting. If so, mould will begin to form. This is best dealt
with by wiping the mould away with a paper towel and
then airing out the glass for a while.

Get to know your miniature landscape

Like our gardens outdoors, miniature landscapes require
attention and care in terms of watering, pruning and
trimming. Moss landscapes in pots or open vessels must
be watered very carefully. Complementary plant spe-
cies, the nature of the soil, and the size of the pot and its
location, of course, are all important in determining how
much water has to be added, and how often. As mentioned,
all mosses require high humidity. If you water your mini-
ature landscape once a week like other potted plants, the
moss and the plants in the landscape are likely to die. But
if they are watered too much and too often, the soil be-
comes too wet and the plants that complement the moss
are at risk of root rot. One method is to use both a water-
ing can and a plastic pipette for the soil. Most species of
moss prefer a moist substrate that may dry up on top but
which is always slightly moist underneath.

In the art of bonsai, there is an expression that goes:
'On a bonsai it always rains twice.' The same principle
can be applied to watering a miniature landscape in an
open pot. This means that you first moisten the soil or
the surface with a plastic pipette and then wait a minute
before you shower the moss abundantly with a watering
can. This allows the soil to become moist, and the moss
to take in water from above as well.

If you create a landscape in a very small pot, it is im-
portant to remember that soil and moss will dry up quickly.
A rule of thumb is to water once a day during autumn and
winter and twice a day – morning and evening – during
summer. If you want to be sure that the soil under the

moss is moist you can lift and feel the weight of the vessel. Is it lighter than usual? Then the soil is too dry. You can also put a small stick into the pot, poking it into the soil and leaving it for a while. On removal, if the part that has been in the soil is dry, it is time to water your landscape. It is difficult to give absolute answers to how often and how much moisture your landscape needs. You will learn through experience. Study your landscape's behaviour carefully and get to know your plants.

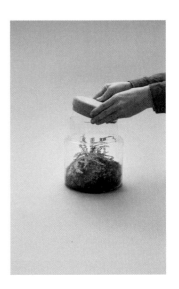

1. Start by washing your glass vessel so it's clean before you start planting. Then cover the bottom of the vessel with 1–2cm of sand. For this terrarium we used black aquarium sand.

2. Cover the sand with a 5–10cm layer of soil suitable for acid-loving plants. Press the surface so that the soil layer feels compact and then spray the soil with water until it is even and slightly damp.

3. If you want plants other than moss in your plant terrarium, place them in the container. Make sure that some of the plant's own soil around the root ball is included. Then cover the gaps with additional soil or peat and remove leftover soil with a brush or stick.

4. Take a piece of moss with some of its original substrate still attached. Sprinkle the underside with water so that it is moist. Press the piece of moss on to the soil and build with new pieces like a puzzle until the entire surface is covered. Leave a small gap between the moss and the root of the plant, so that oxygen and necessary moisture can enter the soil easily.

5. Wipe the inside of the glass with a paper towel and then sprinkle the moss with water.

6. Rotate the glass and make sure the planting looks good from all directions. If you think it looks good, just put on the lid or close your vessel. Your plant is ready!

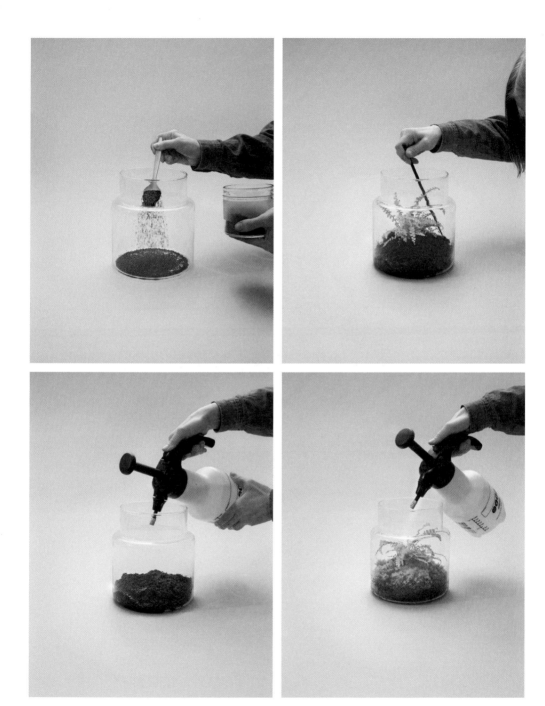

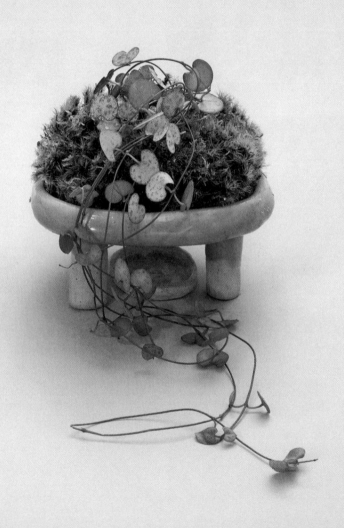

Making a small decorative moss pot

Materials and tools:

- small clay pot or dish
- a square of plastic sheeting
- 1 piece of steel wire
- kiryu
- keto
- compost
- a plant such as *caropegia linaris woodii*
- spoon
- spray bottle

This project is not just about creating a vessel for a plant to live in. It is about creating an aesthetically pleasing miniature landscape. A small jar may be glazed in different colours or unglazed in shades of brown and grey depending on what fits the plants best. To get a natural but exciting feeling in a small moss plantation, try to put the plant in the middle of the pot, instead of nearer one side or the other. In the simple little moss pot shown, the semi-succulent climber *Ceropegia linearis* subspecies *woodii* has been placed side by side with the broom forkmoss *Dicranum scoparium*. The pot was made by the potter and designer Lilit Asiryan.

Watering

A landscape in a small pot should be watered at least once a day. Water the soil with a pipette and spray the moss. The moss can be sprayed twice a day, once in the morning and once in the evening. Plants in small pots like the one opposite dry out faster as they contain less soil.

Light

Hang or place your moss pot in indirect sunlight. Avoid placing near windows exposed to excessive sunshine.

Set-up and maintenance

1. Carefully scratch off excess soil from the roots of the plant. Rinse off the root ball under some lukewarm running water. Choose a nice piece of moss and then clean both the top and the underside and sprinkle with water.

2. Cut a piece of plastic sheeting to cover the drainage holes in the pot with a few centimetres spare on each

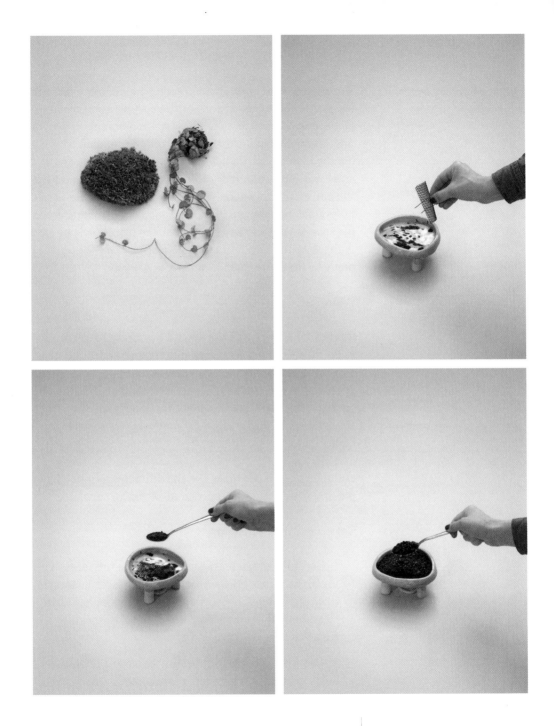

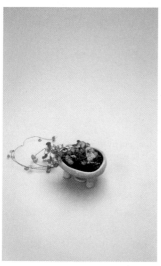

side. Cut a piece of steel wire, shape it into a loop and thread the ends through the fabric. Place the fabric in the pot and attach it by passing the ends of the steel wire through the drain holes and folding them to each side to secure the plastic sheeting on top.

3. Cover the bottom of the pot with a layer of water-retaining granules.

4. Add a layer of kiryu (volcanic sand) and then a layer of soil mix, such as 1 part keto and 1 part potting compost, to just below the rim of the pot.

5. Place the plant in the pot and add a little more soil mix on and around the root ball. Spray with water and pat the soil until it feels compact.

6. Cover the soil with pieces of moss and trim the edges to fit. Remove any leaves that protrude over the edges of the pot.

To maintain the landscape, clear any old leaves and replace moss pieces that lose too much of their original colour.

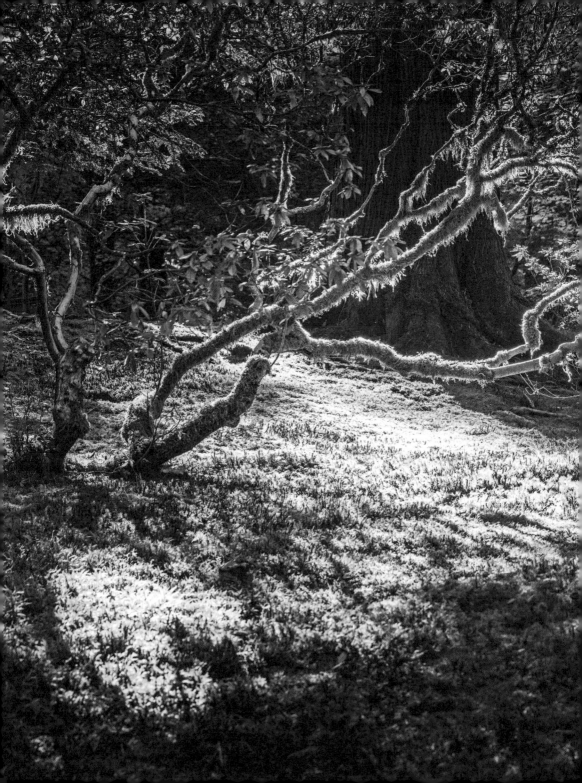

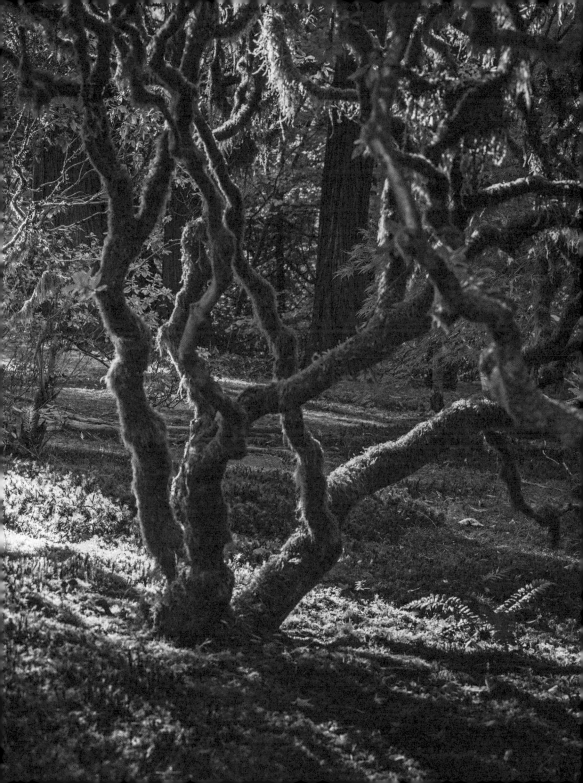

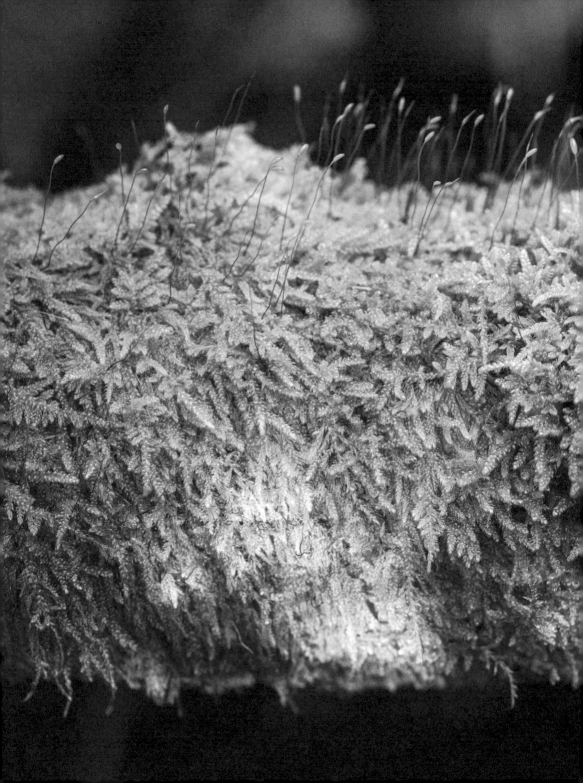

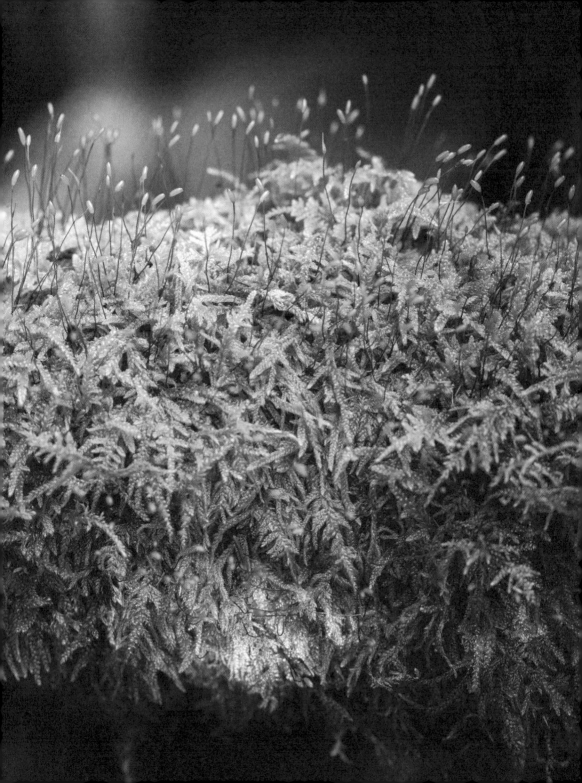

Suggested reading

There is, of course, a wealth of knowledge and reading for those who really want to delve further into the magic world of moss, especially if you want to learn more about identifying different species. Whether you want to study moss in the field or work with it in the garden, it's a good investment to buy a handbook of British moss species. *Mosses and Liverworts of Britain and Ireland. A Field Guide (2010). eds: I. Atherton, S.Bosanquet, M.Lawley.* is a useful book. It is a user-friendly guide to identifying British and Irish bryophytes in the field, with hundreds of colour photographs and black and white drawings showing what species look like, together with notes on how to identify and distinguish similar species, and habitat notes and distribution maps showing where they occur.

Other useful reading can be found at The British Bryological Society's website.

The British Bryological Society organizes meetings, facilitates research and aids measures for conservation. Its worldwide membership, both amateur and professional, is actively engaged in field studies and in the members' interests in taxonomy, exploration and ecology. The British Bryological Society offer specialized advice on matters of public concern affecting mosses and liverworts.

http://www.britishbryologicalsociety.org.uk/

As for Sweden, the National Key to Sweden's flora and fauna includes three volumes of leaf moss. National keys can be ordered at www.nationalnyckeln.se or borrowed from a library. They are encyclopaedias that provide facts about the name, characteristics, way of life and distribution of all species of leaf moss found in the Nordic region. In addition to the fact that they contain a huge amount of information, the mosses are beautifully illustrated with watercolour paintings and colour photographs. A real jewel for all moss fans!

For those who like web-based information, the Art Database has lots of information on different species of moss, animals and natural habitats. In addition to finding information on specific moss species, here you can read more about red-listed species, biodiversity and nature conservation in Sweden: www.artdatabanken.se.

There are a lot of books about the philosophy and plants of Japanese gardens, but unfortunately there isn't much popular science literature available for those who are interested in building a moss garden. There are two American garden books that deal with moss gardens: George Schenk's *Moss Gardening: Including Lichens, Liverworts, and Other Miniatures* from 1997 and Anne Martin's *The Magical World of Moss Gardening*, which came out in 2015. Both of these books contain practical examples of how to make a moss garden and also contain some useful tricks and tips on how to work with moss in your garden. I myself benefited from the Swedish University of Agricultural Sciences (SLU) academic papers and publications about moss in the countryside and gardens during the writing of this book.

Thank you

To all people who shared their knowledge and passion for the world of moss both in face-to-face meetings and by writing to me. You have made this book possible.

Glossary

acrocarp A moss with an upright habit on which the female sex organs grow at the tips of the stems or branches. Compare with pleurocarp.

animism A religious perception that nature is occupied by a spirit.

Anthocerotophyta The hornworts or foliage mosses.

archegonium The female part of a moss plant.

bryolo- Relating to the doctrine and study of moss: bryology involves, among other things, studying the systems, reproduction and ecology of moss.

Bryophyta The leaf mosses.

gametophyte The visible part of a moss species' life cycle, consisting of stem and leaves, and female and male plants. It grows from a spore that may have travelled a long distance before becoming established. It has one set of chromosomes. *See also* **spores**, **sporophyte**.

gemma (*pl.* gemmae) The bud or stalk on a moss plant that can break off to form a new, identical moss plant. This type of reproduction is asexual, or vegetative.

genus A group of closely related organisms consisting of one or more species. Each organism has a Latin name consisting of genus + species (e.g. *Funaria hygrometrica*); this is known as binomial classification. *See also* species, spp., taxonomy.

herbicide A chemical substance used to control weeds.

hypertufa A synthetic aggregate of concrete, peat and sand or gravel suitable for colonising with moss.

kokedama Means 'moss ball' in Japanese; a Japanese plantation technique that is popular in the West. The root system of a plant is surrounded with a ball of soil and moss, and hung up on display.

Marchantiophyta The liverworts or liver mosses.

pH value A measure of acidity in, for example, water or soil. The scale ranges from 0 to 14. pH 7 is called 'neutral' (the pH of pure water). Anything below pH 7 is acidic, whereas anything above pH 7 is alkaline (or 'basic'). Many moss species grow best on substrates that have an acidic pH, below 7.

pleurocarp A moss with a creeping growth habit which forms mats with the female sex organs at the end of short side branches. Compare with acrocarp.

rhizoids Small hairs that attach a moss to its substrate (in the absence of roots); they sit on the stem or underneath the moss, depending on the species.

Shinto A Japanese native religion, sometimes also known as Shintoism. Shinto can be characterised as a form of animism and is to a great extent a cult of natural spirits.

species A group of organisms that can only reproduce with other organisms of the same group. Each organism has a Latin name consisting of genus + species (e.g. *Funaria hygrometrica*); this is known as binomial classification. *See also* genus, spp., taxonomy.

spores The cells produced by the sporophyte stage of the moss life cycle. Very light, spores can be transmitted long distances

by wind or by becoming attached to animal fur. When a spore settles it grows into a new gametophyte. *See also* gametophyte, sporophyte.

sporophyte The sexually propagating part of a moss's life cycle. It has two sets of chromosomes in each cell. It consists of a foot, capsule shaft, capsule and lid. Sporophytes grow out of the gametophyte when a female plant has been fertilised and sits with it throughout its development. *See also* gametophyte, spores.

spp. Literally, the plural of *species*. Used to collectively refer to several species in a certain genus; for example, 'mosses of *Sphagnum* spp.'. See also genus, species, taxonomy.

symbiosis A mutually beneficial relationship in which two organisms share a resource or live in a combined state, with both gaining from the relationship. A lichen is a symbiosis between an alga and a fungus.

taxonomy The science of classifying plants and animals based on their shared characteristics. Traditionally this was based on shape and form, and used visual and measureable characters. With the development of molecular technology, however, increasingly taxonomy is based on DNA studies. Taxonomic groups have a scientific or Latin name, and a common name (for example, Bryophyta, which are the mosses). *See also* genus, species, spp.

vascular plants The largest group of land-growing plants, such as shrubs, trees and herbs. Includes approximately 300,000 species and divided into the club mosses, horsetail ferns, conifers and flowering plants.

Wabi-sabi A Japanese worldview or aesthetic; a doctrine for creating environments for reflection and meditation both indoors and outdoors.

Index